LEGENDARY

OF

INTOWN ATLANTA

GEORGIA

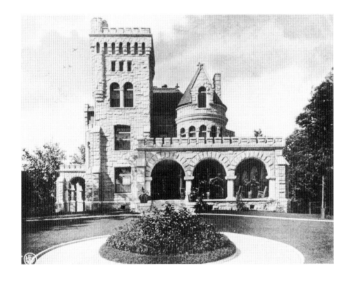

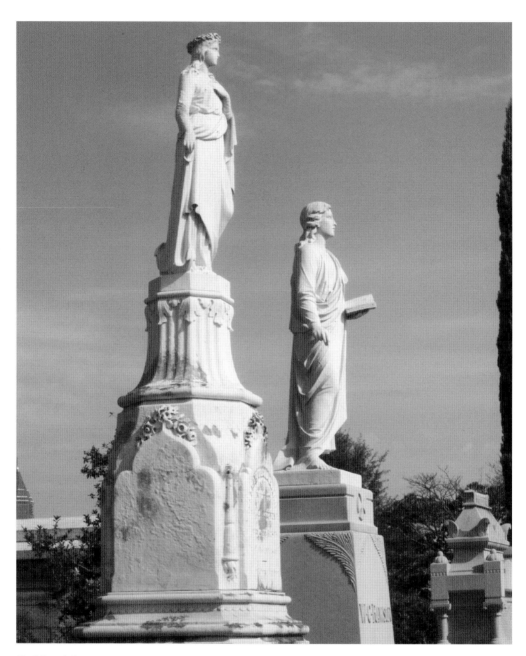

Oakland Cemetery
Oakland Cemetery, founded in 1850 as Atlanta Cemetery, sits on six acres of land just east of downtown. Known for its incredible funerary art and statues, it is the final resting place for many of Atlanta's most celebrated historical notables. Martha Atalanta Lumpkin Compton, Margaret Mitchell, Bobby Jones, and Maynard Jackson are among those buried here. (Courtesy of McDonald.)

Page 1: Rhodes Hall
Rhodes Hall was built in 1904 for furniture magnate Amos Rhodes. (Courtesy of the Georgia Trust for Historic Preservation.)

LEGENDARY LOCALS
——————— OF ———————

INTOWN ATLANTA
GEORGIA

JANICE MCDONALD

LEGENDARY
LOCALS

Legendary Locals is an imprint of Arcadia Publishing
Charleston, South Carolina

Printed in the United States of America

Library of Congress Control Number: 2013948241

For all general information, please contact Arcadia Publishing:
Telephone 843-853-2070
Fax 843-853-0044
E-mail sales@arcadiapublishing.com
For customer service and orders:
Toll-Free 1-888-313-2665

Visit us on the Internet at www.arcadiapublishing.com

Dedication
This book is dedicated to the people who helped shape Atlanta into what she is today.

On the Front Cover: Clockwise from top left:
John Gill, rock climbing innovator (Courtesy of John Gill; see page 123), Xernona Clayton, civil rights activist (Courtesy of Xernona Clayton; see page 81), Brenda Lee, singer (Courtesy of Brenda Lee Productions; see page 103), Dr. Henry Rutherford Butler, physician and pharmacist (Courtesy of the Auburn Avenue Library; see page 21), Bobby Jones, golfer (Courtesy of Georgia Tech; see page 122), Dorothy Alexander, Atlanta Ballet founder (Courtesy of Atlanta Ballet; see page 100), John Brown Gordon, post–Civil War governor (Courtesy of the Library of Congress; see page 24), Ty Pennington, TV personality (Courtesy of Ty Pennington; see page 104), Selena Sloan Butler, educator and activist (Courtesy of the Auburn Avenue Research Library on African American Culture; see page 88).

CONTENTS

ACKNOWLEDGMENTS

This book has been a labor of love. It has stirred my own memories and impressions of Atlanta and its people, and has also required me to tap into the memories of others. As much as I thought I knew of Atlanta, I learned so much more and am even prouder to call this city my home.

During my time in Atlanta, I have come to know a great many of the contemporary people featured in this book (or I know people that knew them). I was able to reconnect with several of these people and share some special memories. It's been fun to give them a little added recognition and credit for their contributions, both big and small. So many of the legendary locals found here were obvious choices, while others were, perhaps, less so. People have been very willing to share tales of neighbors, relatives, and friends and to point out people who might have been overlooked. All of those included here have made an impression on countless others and an impact on Atlanta itself. That's what matters.

So many people leapt at the opportunity to help contribute. I have told each and every one of them that this has been like herding cats. You simply could not go to one source to get what was needed for this book. I had folks digging in attics, pulling books out of storage, and, of course, there were hours spent combing through libraries for what I call "treasure hunting." I want to thank my mother, Dorothy McDonald, for rooting me on (as always), and George Drake for talking me through so much of this and pushing me to keep moving. Also, the following people are just some of those that have given their patience and guidance in helping to track down the photographs needed to illustrate these people and their stories: Jane Hudson, Tom Houck, Sheila Hula, Debbie DiBona, Karen Rosen, Barbara Lynn Howell, Steve Green, Robert Cabell, Erin Levin, Sandee LaMotte, Ben Chappell, Justine Fletcher of Coca-Cola, Mary Palmer Linnemann of UGA, Christine D. de Catanzaro of Georgia Tech, and Sara Logue of Emory.

The images in this volume from the following institutions have been abbreviated in the courtesy lines: the Georgia State Archives (GSA), the Atlanta History Center (AHC), and the Library of Congress (LOC).

INTRODUCTION

It would be virtually impossible to list all of the people who have made their lasting mark on Atlanta since its beginnings in the early 1800s. This book, *Legendary Locals of Intown Atlanta*, can only highlight a select few of those whose stories are so compelling and whose impact continues to be felt today.

Atlanta's rapid growth, from its starts as a railway crossroads in the uncivilized territory of north Georgia to the world-renowned city it is today, can be directly attributed to its people. This book celebrates some of the key players along the way and the contributions they have made.

These legendary locals come from all walks of life. Some were born here, while others moved here. Some were here their entire lives, while others were here just long enough to make their mark. Some of them gained notoriety for their dogged determination and accomplishments, while others are noted for less auspicious reasons. But for better or worse, each has made their mark here. Many of their names are easily recognized. Their efforts were rewarded by having their names emblazoned on streets, buildings, and parks across Atlanta. Grant Park, Hurt Park, Ivy Street, and Fulton County are all namesakes of those from the early days.

Atlanta is a city that, from its earliest days, seems to draw people and inspire ambition. Few cities can say that the people who have called it home over the centuries have had such global influence. The term "Atlantan" can be tacked on next to countless notable names, including industry leaders, politicians, inventors, actors, authors, and educators (or those whose life's work has been to help and inspire others). Some of the world's best-known brand names were conceived and launched in Atlanta: The Home Depot (Thank you Arthur Blank and Bernie Marcus!); Chick-fil-A, Truitt Cathy; and the Cable News Network (CNN), Ted Turner. Aficionados of Coca-Cola like to say that every Coke across the globe has a little bit of the Chattahoochee River in it. Atlanta is where the brown elixir was first concocted in the 1800s, and the secret formula to that potion is still locked up here at the Coca-Cola museum (just down from Coke's world headquarters).

The spotlight of the world has shown upon Atlanta on numerous occasions because of its people—from the ravages of the Civil War to the global influence exerted during the civil rights movement of the 1960s—led by Rev. Martin Luther King Jr.—and then, of course, the 1996 Olympic Games.

But yet, there are also countless lesser-known Atlantans whose visions and tenacity have impacted others in a lasting way that, like a pebble in a pond, has caused a ripple effect. Those people include Atlanta depot maid Carrie Logan, who became concerned over young black children loitering in the rail yards and began taking them in, eventually starting the first black orphanage in the United States. It is still active today. Another innovator was Freddy Lanoue, a diving and swimming coach who developed a technique that would "drown proof" those forced to spend prolonged time in the water.

To truly understand how Atlanta has become what it is today, one must be familiar with those who were involved in its development and understand a little behind their motivations. When the first settlers began moving in (after the 1829 displacement of the Creek Indians), no one could have fathomed that this spot in the north Georgia wilderness would grow into an internationally recognized center of commerce.

It all started with a man named Hardy Ivy, who is credited to be the first of European descent to make his home here. In 1833, he purchased a plot of 220.5 acres of land (at the heart of what is now downtown Atlanta) and built a double-sized cabin. Within four years, surveyors were laying marks to the west of Ivy's property for the building of the Western & Atlantic Railroad (W&A). The Georgia Railroad already connected Augusta to the capital in Milledgeville, and it would expand north to meet the W&A. They would converge in north Georgia at an area on the Chattahoochee River where three granite ridges came together. As the building of the railroad began, railroad surveyor Stephen Long predicted the area

"will be a good location for one tavern, a blacksmith shop, a grocery store, and nothing else." The area got that (and more) and is still growing.

The population of the region began to boom. Speculators and visionaries moved to the area, buying up land and starting businesses. They first called their little town Terminus, then Marthasville, before finally settling on Atlanta. In 1845, the town got its first mayor, Moses Formwalt. He served only a year, but kick-started efforts to establish order in the town by getting roads cut, wells dug, and a jail built. People like Lemuel Grant, Richard Peters, and Samuel Inman made their mark by steering many decisions about how this new town would run.

Atlanta's railroads made it a target during the Civil War. Gen. William Tecumseh Sherman of the Union army declared a scorched-earth policy to lay waste to the growing city. But even burning the city and tearing up its railroads could not halt what had already started. When the war was over, Atlanta rose from the ashes. In 1868, railroad man Hannibal Kimball succeeded in his efforts to have the capital moved to Atlanta. Expansion and growth was steady, and Atlanta became a city of many firsts. Since then, there has been no stopping Atlanta's growth and the vision of those driving it. Mayor William Hartsfield pushed to build a world-class airport. Hartsfield-Jackson International Airport is now the world's busiest.

The civil rights movement found a home and a fire beneath Atlanta, and it became known, as Mayor Ivan Allen Jr. would put it, as "the city too busy to hate." A proud team of Atlantans pursued the Olympic dream and was able to bring the World and 1996 Centennial Olympic Games to Atlanta. That added global recognition seems to have only inspired the city and its people further. There is no shortage of legendary locals in Atlanta and no shortage of legendary locals in the making.

CHAPTER ONE

Those Who Paved the Way

The early pioneers of Atlanta could not have known that they would be laying the groundwork for a city that would, eventually, have the global impact it does today. When the first European settlers moved onto what was once Indian land, day-to-day life was about staking a claim for land and establishing a place for one's family. As soon as the decision was made to build rail lines converging in a north Georgia location, destiny was set in motion for the area's future. Any place where several lines came together was destined to grow. A town was needed to support those all-important railroads, which meant that the town of Terminus would also grow in importance. Oh, if they only knew. At that time, railroads were propelling the growth of the United States beyond the original colonies. Many people hitched their fate and fortune to the railroads, and that gamble paid off time and time again.

What helped set Terminus apart from other rail towns were the people who built and shaped it. As the town grew, the name changed to Marthasville before being renamed as Atlanta. It became a destination for those who wanted to make their fortunes, either through their own vision or by working hard with other visionaries. It is a trend that continues to this day. Many a dream born in Atlanta has become a reality, eventually impacting the world. Atlanta's importance made it a good target during the Civil War, but, as devastating as the war proved to be, it could not undo what had already been established. Atlanta had a reputation, and the destruction wrought by combat simply left room to rebuild the city bigger and better. This chapter celebrates those who paved the way.

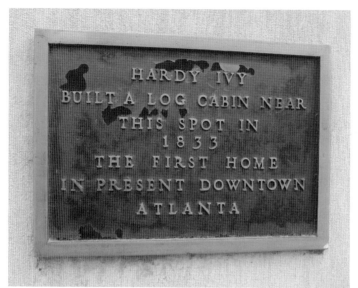

Hardy Ivy

Hardy Ivy—who, in 1833, spent $225 to purchase Lot No. 41, which included 220.5 acres of land—built the first cabin built in what ultimately became Atlanta. This plaque, located on the corner of John Wesley Dobbs and Peachtree Center in downtown Atlanta, marks the site. Ivy, who died in a fall from his horse in 1842, is believed to be buried near his cabin. (Courtesy of McDonald.)

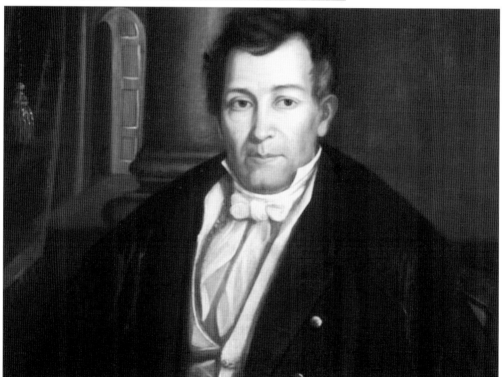

Wilson Lumpkin

Wilson Lumpkin grew up in Oglethorpe County, studying law and serving in the Georgia House of Representatives and the US Congress before becoming Georgia's governor in 1835. While governor, Lumpkin also served as a commissioner for the Cherokee Indian Treaty. Admiring voters attempted to rename the growing town of Terminus "Lumpkin" in his honor, but he deferred instead to his daughter Martha. He was later elected US senator. (Courtesy of LOC.)

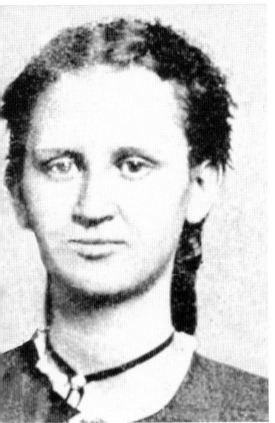

Martha Atalanta Lumpkin Compton
In 1843, Georgia governor William Lumpkin renamed the growing town of Terminus—which was located in the center of the state—"Marthasville," after his youngest daughter. Martha Lumpkin Compton's namesake quickly came to be considered not grand enough by some residents. Still paying homage to Martha Lumpkin, the city was renamed "Atlanta" in 1845. The family bible lists her full name as Martha Atalanta Wilson Lumpkin. (Courtesy of AHC.)

Richard Peters
Born to a prominent Philadelphia family, Richard Peters moved to Marthasville as superintendent of the state railroad. He is credited with pushing to change the name to Atlanta. He established numerous businesses, including Atlanta's first steam-powered cotton mill. In order to have wood to generate steam, Peters bought 405 acres in what is now Midtown. He later subdivided the land, donating four acres to establish the Georgia School of Technology, now known as Georgia Tech. (Courtesy of AHC.)

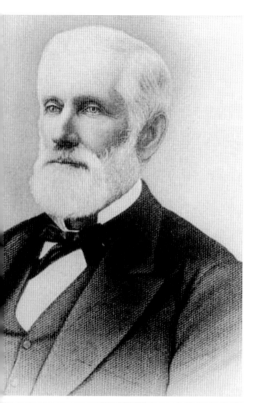

Lemuel Grant

Lemuel Grant moved from Massachusetts to work on the railroad. He partnered with Richard Peters to complete the Georgia Railroad. A civic leader and banker, Grant bought more than 600 acres of land in southeast Atlanta in 1843. He donated 108 acres of his property to become a city park. Grant stipulated that Grant Park would be free for use by people of any race, creed, or color. (Courtesy of GSA.)

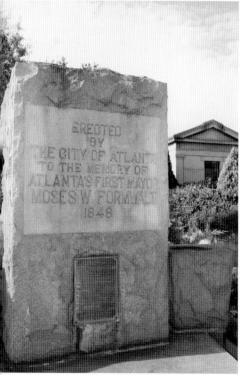

Moses Formwalt

Moses Formwalt was a tinsmith making stills when he decided to run in Atlanta's first mayoral election in 1848. Representing the Free and Rowdy Party, Formwalt easily won the majority of the 251 votes available. During his one-year term, he earned praise for cutting more roads and building Atlanta's first jail. While serving as deputy sheriff, Formwalt was stabbed to death escorting a prisoner. (Courtesy of McDonald.)

Sidney Root

Sidney Root's international business dealings helped propel Atlanta onto the global business stage. A religious man, Root was a close friend of Confederate president Jefferson Davis, playing several key roles in maintaining the Confederacy. Post–Civil War, he advocated higher education for African Americans, serving as a trustee for both Spelman Seminary and the Atlanta Baptist Seminary (Morehouse College). Root demanded that there be no social, gender, or racial segregation. (Courtesy of Hargrett Rare Book and Manuscript Library, University of Georgia Libraries.)

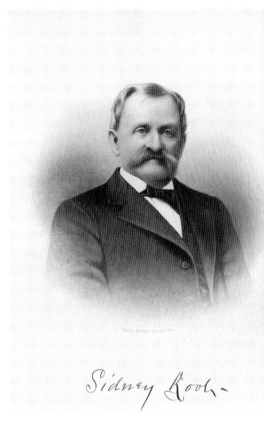

Edward Arista Vincent

Before moving to the United States, Edward Vincent trained as a cartographer and engineer in his native England. After mapping Savannah, he moved to Atlanta in 1852 to build the Western & Atlantic Railroad's passenger depot. The Atlanta city council hired him to map the city. General Sherman's men used Vincent's subdivision map of the city of Atlanta to help plot their destruction of the city during the Civil War. (Courtesy of LOC.)

13

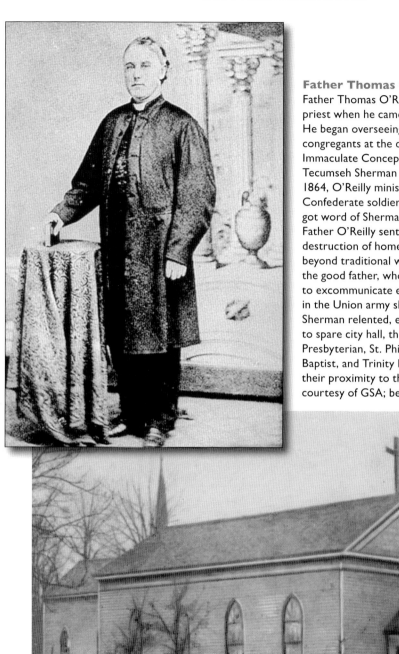

Father Thomas O'Reilly

Father Thomas O'Reilly was a missionary priest when he came to Atlanta in 1848. He began overseeing the small flock of congregants at the downtown Church of the Immaculate Conception. When Gen. William Tecumseh Sherman laid siege to Atlanta in 1864, O'Reilly ministered to both Union and Confederate soldiers. Outraged when he got word of Sherman's plans to burn Atlanta, Father O'Reilly sent word to the general that destruction of homes and churches went beyond traditional warfare. Sherman ignored the good father, who countered with a threat to excommunicate every Catholic soldier in the Union army should his church burn. Sherman relented, eventually also agreeing to spare city hall, the courthouse, Central Presbyterian, St. Phillip's Episcopal, Second Baptist, and Trinity Methodist because of their proximity to the Catholic church. (Left, courtesy of GSA; below, courtesy of AHC.)

Dr. Joseph P. Logan

Dr. J.P. Logan was one of Atlanta's first trained medical doctors. Numerous accounts of the 1864 Battle of Atlanta take note of his heroic and compassionate efforts to treat the wounded and ease their suffering. While teaching at the Medical College in 1866, Dr. Logan helped organize the Atlanta Memorial Association to honor and bury the Confederate dead. Dr. Logan was the association's first president. (Courtesy of McDonald.)

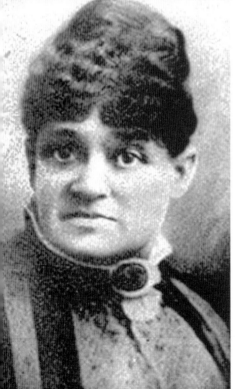

Carrie Steele Logan

Despite being born a slave, Carrie Steele Logan learned to read and write. While working as a maid at Atlanta's Union Station, she began caring for the homeless black children who loitered around the trains. She solicited funding and built Georgia's first orphanage for black children in 1888. Originally known as the "Carrie Steele Orphan Home," today's Carrie Steele-Pitts Home remains the oldest predominately black orphanage in the United States. (Courtesy of the Carrie Steele-Pitts Home.)

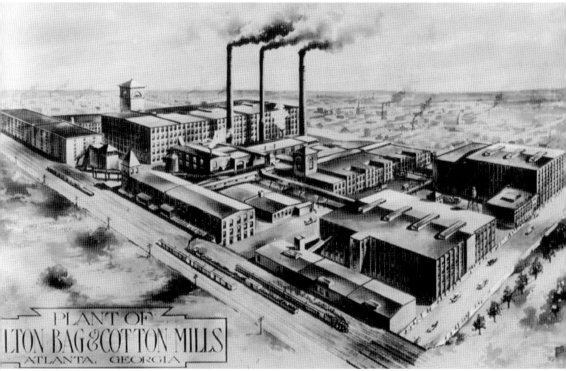

PLANT OF
[L]TON BAG&COTTON MILLS
ATLANTA, GEORGIA

Jacob Elsas and Isaac Mays
A German immigrant and Union army veteran, Jacob Elsas came to Atlanta to work in dry goods. He was already running three businesses when he joined forces with fellow immigrant Isaac May. In 1872, they established Elsas, May and Company to manufacturer cloth and paper bags. Their mill became known as the Fulton Spinning Company and was one of the earliest cotton mills in Atlanta. As business grew, they purchased eight acres of land and refurbished the Atlanta Rolling Mill, which was destroyed during the Civil War. In 1881, homes were built near the new Fulton Bag Company to house some of the factory's more than 100 workers. The region was called Factory Town and is now known as Cabbagetown. (Above, courtesy of ACH; left, courtesy of McDonald.)

Hannibal Kimball

Hannibal Kimball is known for the great successes and failures he incurred while living in Atlanta. He was partner in a large carriage building company when, in 1867, he moved to Atlanta to help the Pullman Company build sleeping cars for trains. Kimball was instrumental in moving the state capital from Milledgeville to Atlanta, where he constructed the first capitol building. As a partner in the Atlanta Water and Canal Company, he helped establish Atlanta's first sewer system. Kimball was president of nine railroad companies, building a new depot for Atlanta and constructing more than 300 miles of track in the Southeast. He built the massive H.I. Kimball House Hotel to accommodate those traveling to Atlanta for business. Kimball's railroad businesses eventually failed, but he went on to successfully manage the 1881 International Cotton Exchange. In 1884, he and Richard Peters attempted to develop 200 acres of land—along what is now West Peachtree—into a neighborhood called Peter's Park. That venture also failed. (Right, courtesy of Wallace Putnam Reed; below, courtesy of McDonald.)

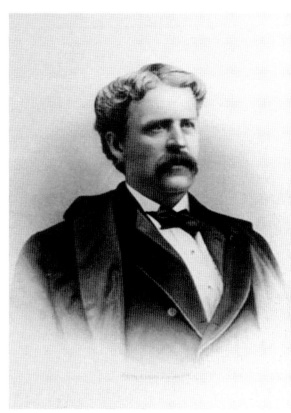

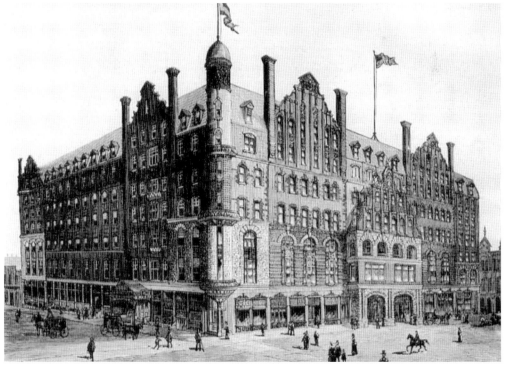

Joel Hurt

Joel Hurt began his career as a railroad surveyor. In 1875, he moved to Atlanta and helped establish the Atlanta Building and Loan Association. Hurt also cofounded the Trust Company Bank of Georgia (now part of SunTrust). In 1885, Hurt founded the East Atlanta Company to create and develop Inman Park. He connected the new neighborhood to downtown Atlanta with a streetcar. Hurt also originated the development of Druid Hills. (Courtesy of AHC.)

Samuel Martin Inman

Samuel Inman partnered with Joel Hurt to establish the new neighborhood east of downtown that would come to be known as Inman Park. His main business was cotton. In 1889, S.W. Inman & Co. was the largest mill in Atlanta and had a branch in Houston, Texas. Inman was among the first to donate money toward the establishing of the Georgia School of Technology. He also convinced Richard Peters to donate land for the school. (Courtesy of AHC.)

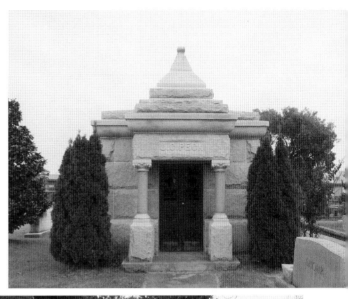

John C. Peck

If it needed to be built in Atlanta during the late 1800s, John Peck was the man to do it. Considered Atlanta's premier builder of his time, he built the original capitol building, the first Kimball House, the original buildings at Fort McPherson, the buildings at the 1881 International Cotton States Exposition, and the buildings at the old Piedmont Exposition. (Courtesy of McDonald.)

Edwin Ansley

Edwin Ansley used his law degree to help further his passion for real estate development. Sensing the importance of having good transportation thoroughfares for the growing city of Atlanta, Ansley successfully lobbied city council to create Forsythe Street as a crosstown connector in downtown. In 1902, he designed and developed Ansley Park—the first suburb specifically designed to accommodate automobiles. (Courtesy of McDonald.)

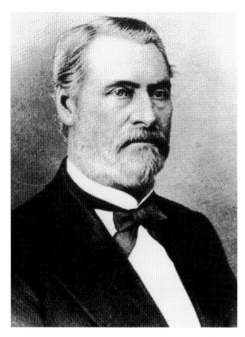

Alfred Austell

One of the largest cotton dealers of his time, Alfred Austell was also known for building banks and railroads. In 1858, Austell—a cashier at the National Bank of Fulton—helped to establish both the Atlanta National Bank and the Atlanta Savings Bank. A supporter of transportation initiatives, he built the Atlanta and Charlotte Air Line, as well as the Spartanburg-Asheville branch of what later became the Southern Railway. (Courtesy of GSA.)

Helen Dortch Longstreet

Helen Dortch Longstreet earned the nickname the "Fighting Lady." The widow of Confederate general James Longstreet, she fought relentlessly (even long after his death) to defend her husband's reputation. A journalist, she was the first woman to hold the office of state librarian, was the first female state archivist, and ran an unsuccessful campaign for governor against Herman Talmadge in 1947. Longstreet was the first woman to have a portrait in the Georgia State Capitol. (Courtesy of LOC.)

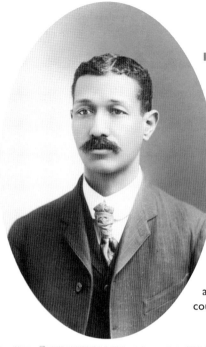

Henry Rutherford Butler

A pioneer in medicine and health care for African Americans in the late 1800s, Henry Rutherford Butler is credited with starting the first licensed black-owned pharmacy in the state of Georgia and cofounding several physician organizations. The North Carolina native moved to Atlanta in 1890 and served as surgeon of the 2nd Georgia Battalion, Colored Volunteers. Among the groups he helped establish are the Atlanta Medical Association of Physicians, Dentists, and Pharmacists (later the Atlanta Medical Association) and the Georgia State Medical Association of Physicians, Dentists, and Pharmacists (later the Georgia State Medical Association). A prolific writer, Butler was very active in the community and was particularly interested in mentoring young men. He was instrumental in founding the Butler Street YMCA, as well as District 10 of the Boy Scouts of America. (Both images courtesy of the Auburn Avenue Research Library.)

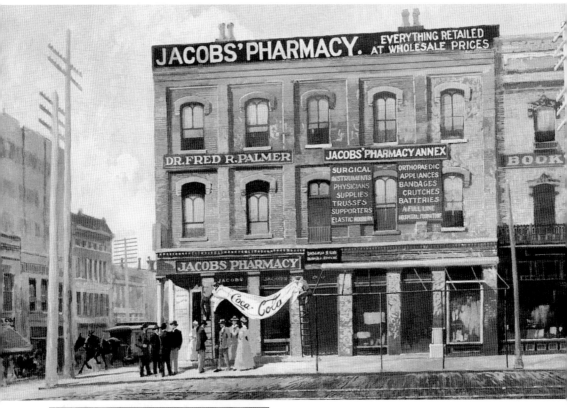

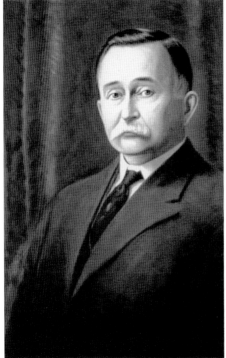

Dr. Joseph Jacobs

Dr. Joseph Jacobs was a successful pharmacist and owner of Jacobs' Pharmaceutical Laboratory in Athens. In 1884, he bought a competitor's drugstore in Atlanta's Little Five Points. At one point, there were 16 Jacobs' Pharmacy locations. In 1887, fellow pharmacist Dr. John Pemberton asked Jacobs to sell a new drink he had created. Jacobs' Pharmacy was the first to sell Coca-Cola as a fountain drink. (Courtesy of The Coca-Cola Company.)

Frank Robinson

A bookkeeper for pharmacist John Pemberton, Frank Robinson is credited with choosing the name "Coca-Cola" for Pemberton's caramel-colored, carbonated drink. He wrote the name down in his distinctive handwriting, a script that continues to be used to this day. When Asa Candler purchased the formula and formed The Coca-Cola Company, Robinson worked as secretary and treasurer and was involved in advertising. He remained a company director after his retirement in 1914. (Courtesy of The Coca-Cola Company.)

CHAPTER TWO

The Leaders

There are followers and there are leaders. Since its beginnings, Atlanta has known more than its fair share of leaders. Virtually everyone in this book is a leader in their own right. They are deemed "legends" because of their accomplishments. This chapter acknowledges those whose lasting impact on the city, state, and, sometimes, the world has earned them respect and admiration. For some, this holds true decades later.

Maya Angelou once said of leaders, "If one is lucky, a solitary fantasy can totally transform one million realities." The leaders in this chapter built Atlanta by turning their ideas and fantasies into realities. Among the many applauded here are those elected to leadership, who used the public trust to deliver on a promise. They include the likes of Georgia's post–Civil War governor John Brown Gordon, who insured that the state and Atlanta would not be run by the corrupt politicians who had come to power in the turmoil of the war's aftermath. Atlanta mayor William Hartsfield had a fantasy in the 1940s that his city should be a national aviation center. Hartsfield-Jackson Airport is now the world's busiest airport.

Some leaders' impact was not always entirely positive. There were those in the early days who, while pushing growth and development, did not see that racial equality would be key to going forward. Luckily, those who were truly forward thinking have, in the end, made the greatest impact. We can argue that all of Atlanta's leaders, the good and the bad, have created the city that we enjoy today.

John Brown Gordon

John Brown Gordon was a lawyer in Atlanta when the Civil War broke out. He was one of Confederate general Robert E. Lee's most trusted generals. Following the war, Brown was elected US senator twice, interrupting his terms to serve as 53rd governor of Georgia (1886–1890). A proponent of the New South, he successfully convinced Pres. Ulysses Grant to remove any federal officials from Georgia who gained their postwar positions via corruption. (Courtesy of LOC.)

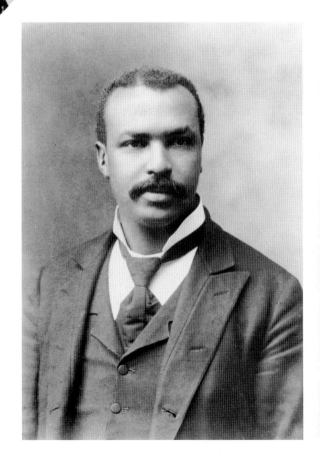

Henry Hugh Proctor

Hugh Proctor was the minister at First Congregational Church in Atlanta. During the race riots of 1906, he helped quell tensions by bringing 20 blacks and 20 whites together to create the Interracial Committee of Atlanta. Through his church, Proctor helped teach community members life skills that would improve their lives. Proctor also founded the Atlanta Colored Music Festival Association to showcase the talents of classically trained African American performers. (Courtesy of LOC.)

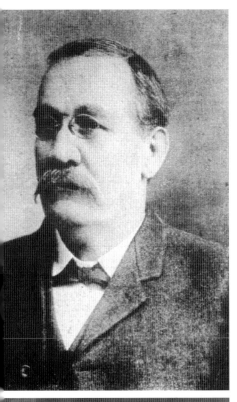

James G. Woodward

In 1899, Atlanta labor leader James G. Woodward first ran for mayor on the motto of being the "Working Man's Mayor." His election signaled the growing power of unions in Atlanta. Serving four terms in three different periods, he was the 36th, 39th, and 43rd mayor. Woodward was in office during the race riots of 1906. When not serving, he was a printer in the newsrooms of the *Atlanta Journal* and the *Constitution*. (Courtesy of GSA.)

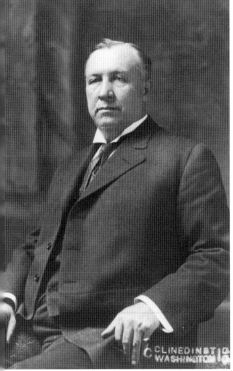

Hoke Smith

In 1887, noted trial attorney Hoke Smith bought the *Atlanta Journal*, using it as a platform for the Democratic Party. During his run for governor in 1906, he inflamed racial tensions by calling for the disenfranchising of blacks so that whites could maintain social order. The result was a race riot in downtown Atlanta. Smith won the governorship. While still serving, he was appointed to fill a vacant US Senate seat. (Courtesy of LOC.)

Hugh Dorsey

Attorney Hugh Dorsey was virtually unknown in 1913, when he defended Jewish factory owner Leo Franks against charges he murdered one of his workers, Mary Phagan. Franks was convicted, but his sentence was commuted. He was lynched by vigilantes. An outraged Dorsey used his notoriety to successfully run for governor on a law enforcement platform. He appointed a commission to investigate violence against blacks and promoted compulsory education for all races. (Courtesy of AHC.)

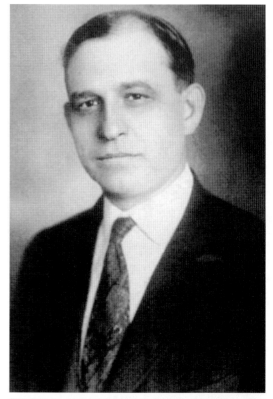

Charles Palmer

In 1933, real estate developer Charles Palmer was instrumental in developing the first federally subsidized housing project in the nation—Techwood Homes. Palmer was a national expert in urban development and helped create the Atlanta Housing Authority. He served as president of the National Association of Housing Officials and was coordinator of defense housing for the National Defense Office for Emergency Management (OEM). (Courtesy of LOC.)

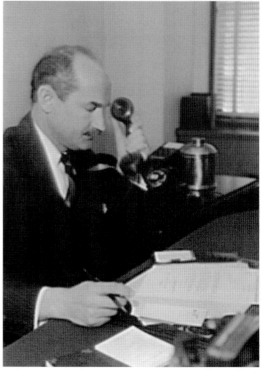

William Berry Hartsfield Sr.

William B. Hartsfield Sr. was the longest serving mayor in Atlanta's history. He served twice, first from 1937 to 1941 and again from 1942 to 1962. As city alderman, he helped establish Atlanta's first airport, and as mayor, he helped develop that airport into a national aviation center. Atlanta's Hartsfield-Jackson Atlanta International Airport is named in his honor (as well as that of later mayor Maynard Jackson). Under Hartsfield's guidance, the city garnered the reputation of "the city too busy to hate." The native Atlantan is also known for ensuring the city's water supply with the completion of the Buford Dam at Lake Lanier. Hartsfield is shown here, prior to a movie premiere at the Fox Theatre, with two unidentified models. (Courtesy of The Fox Theatre.)

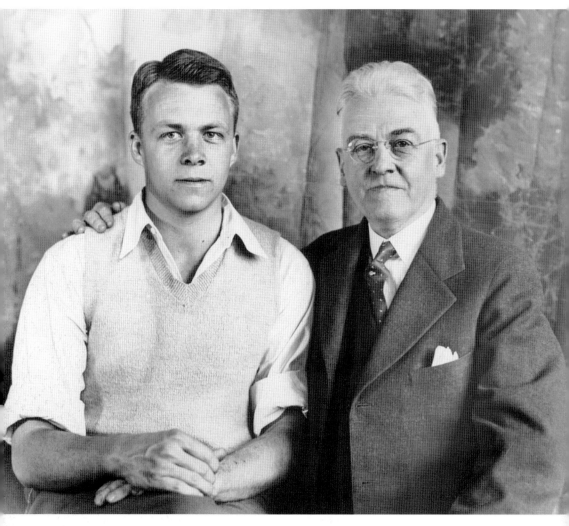

Ivan Allen Sr. & Ivan Allen Jr. (ABOVE AND OPPOSITE PAGE)
This 1932 photograph above shows the father-son duo of Ivan Allen Sr. (right) and Ivan Allen Jr.—true powerhouses in Atlanta. The senior Allen transformed his business of selling typewriters into a multimillion-dollar office supply company. He served as president of the Atlanta Area Chamber of Commerce and was a founding member of the Atlanta Rotary Club. Allen Sr. also led the Forward Atlanta Campaign from 1926 to 1929, helping to bring in new businesses following the devastating fire of 1917. Ivan Allen Jr. served two terms as mayor of Atlanta during the 1960s. While most cities were facing unrest, he brokered a peaceful plan for desegregation and was considered a face of the progressive New South. Allen Jr. persuaded the Milwaukee Braves baseball team to move to Atlanta in 1966 and convinced the National Football League to create the Atlanta Falcons. Two years later, the Atlanta Hawks basketball team was formed. The 1965 image on the opposite page shows Mayor Allen at a press conference at Atlanta Stadium (later named Atlanta-Fulton County Stadium) announcing the arrival of the Braves baseball franchise. (Both, courtesy of AHC.)

Boisfeuillet Jones

An educator and philanthropist, Boisfeuillet Jones earned his law degree at Emory and was instrumental in creating Emory's clinical services, which ultimately became Emory Clinic. Pres. John F. Kennedy brought him to Washington as special assistant for health and medical affairs. Jones then worked with President Johnson to shape the legislation that created Medicare. Upon returning to Atlanta, Jones was tapped as chairman of the Board of Directors of Economic Opportunity Atlanta (EOA). He also chaired a series of high-profile charities, including the Emily and Ernest Woodruff Foundation, the Robert W. Woodruff Foundation, and the Joseph B. Whitehead, Lettie Pate Whitehead, and Lettie Pate Evans foundations. The Boisfeuillet Jones Atlanta Civic Center is named in his honor. (Courtesy of AHC.)

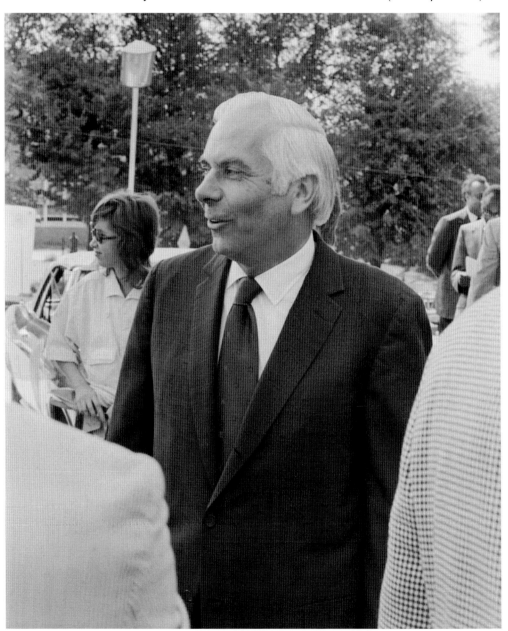

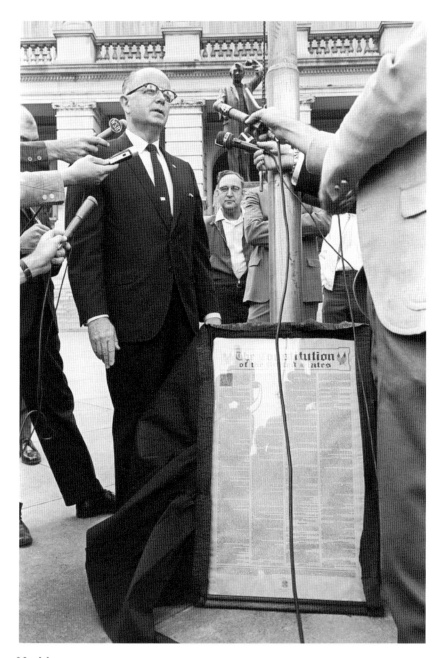

Lester Maddox

Ardent segregationist Lester Maddox served as 75th governor of Georgia (1967–1971) during the height of the civil rights movement. An unlikely candidate, Maddox owned a family restaurant for years before running, even closing down the Pickrick in 1964 rather than desegregating. A Democrat and a populist, he ran for several offices, including mayor of Atlanta, before surprising many by winning the gubernatorial election. Although he refused to support civil rights, Maddox's term was surprisingly progressive. State troopers were urged to address blacks as Mr. or Mrs. (instead of in derogatory terms), farmers markets throughout the state became integrated, and Maddox appointed more blacks to government positions than all of the previous governors combined. (Courtesy of AHC.)

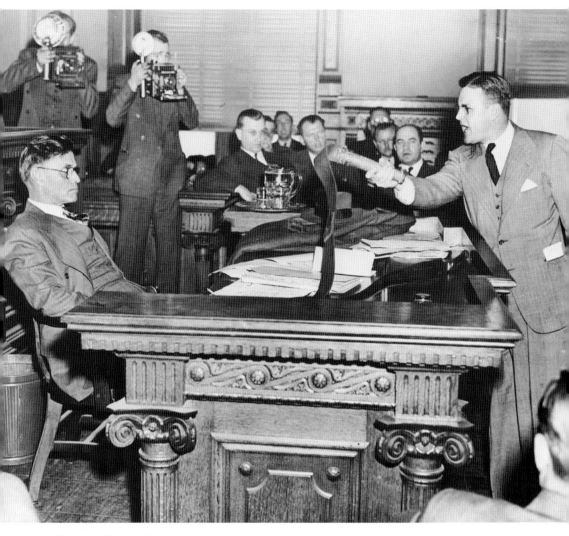

Eugene Talmadge

Outspoken and controversial, Eugene Talmadge served three terms as Georgia's commissioner of agriculture before running for governor. He was very popular among his rural constituents, presenting himself as an advocate for farmers. As governor, Eugene Talmadge used federal subsidies to improve Georgia's state services and reduce the costs of services to taxpayers. Famously, he lowered the price of automobile tags, making them more affordable to all. Talmadge easily won two terms as governor, but when he fired the university board of regents (after they refused to remove two teachers who spoke out against segregation issues), 10 public colleges and universities lost accreditation. Tallmadge lost his next election. In 1946, he won reelection but died before taking office. In this photograph, Talmadge (left) is being questioned by prosecutor Dan Duke during a Ku Klux Klan clemency hearing. (Courtesy of AHC.)

Herman Talmadge

Herman Talmadge was elected governor by the general assembly to fill the spot left vacant when his father died. He vacated office within a year when the Georgia Supreme Court ruled that the move had been unconstitutional. Talmadge easily won a special election the following year. As governor, he enacted a state sales tax and made vast improvements in the educational system. While considered progressive in most areas, he was a staunch segregationist and resisted any attempt to integrate schools. In 1956, Talmadge was elected to the first of four terms in the US Senate, where he worked tirelessly to protect farmers and rural America. He also consistently worked to support bills that would balance the budget. (Courtesy of LOC.)

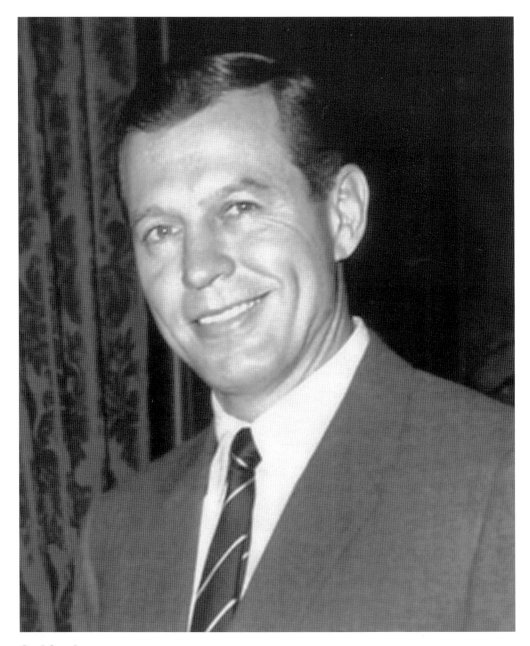

Carl Sanders

Carl Sanders began his career in the Georgia House of Representatives before running for governor in 1962. Sanders was the first modern Georgia governor elected by popular vote and, at the age of 37, was the youngest governor in the United States. Despite his age, he developed a reputation as a strong governor and was noted for leading the state in its transition toward racial desegregation. Sanders recognized the need for change and worked with Pres. John F. Kennedy and Pres. Lyndon Johnson to help assure compliance with new civil rights laws. He also worked to modernize the state government and get rid of corruption. Funding for higher education was increased under his leadership, and he brought extensive economic development to Georgia. (Courtesy of AHC.)

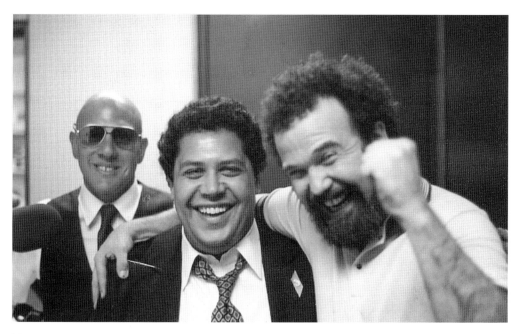

Maynard Jackson

Elected Atlanta's first African American mayor in 1973, Maynard Jackson made his mark on the city by strengthening racial relations and promoting numerous public works initiatives that were designed to improve the city's infrastructure. He was behind the rebuilding of Atlanta's Hartsfield Airport—now called Hartsfield-Jackson in honor of both Jackson and earlier mayor William Hartsfield. Jackson also helped to generate federal funding for creation of the Metropolitan Atlanta Rapid Transit Authority (MARTA). After leaving office, he worked closely with Mayor Andrew Young to bring the 1996 Olympics to Atlanta. In 1990, he began his third term as mayor. Jackson was the grandson of civil rights leader John Wesley Dobbs. Jackson is pictured above (center) with Art Harris (left) and friend Tom Houck. Below, Jackson is shown at city hall. (Courtesy of Tom Houck.)

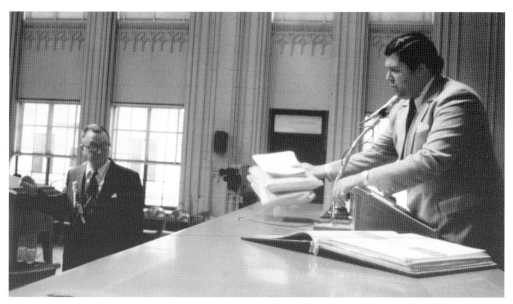

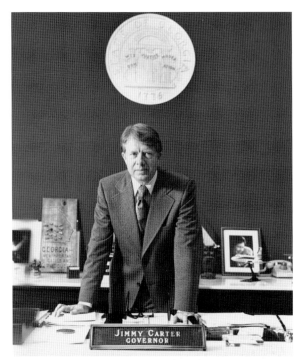

James Earl "Jimmy" Carter

A peanut farmer from Plains, Georgia, Jimmy Carter first moved to Atlanta in 1961 to serve as a state senator. In 1971, he relocated back to Atlanta to serve as governor. Carter made history by proclaiming the end to segregation, saying, "No poor, rural, weak, or black person should ever have to bear the additional burden of being deprived of the opportunity of an education, a job, or simple justice." As governor, Carter reorganized state government to run more efficiently. He held just one term before running for president. Carter's presidency was marred by inflation, recession, and the energy crisis (as well as by the Iran hostage crisis). Leaving office, he won the Nobel Peace Prize for his work with conflict resolution through The Carter Center, which monitors global political and health issues. The photograph above shows Carter in his office as Georgia governor. The photograph on the left shows him aboard the Peanut Express campaign plane. (Above, courtesy The Carter Center; below, courtesy of LOC.)

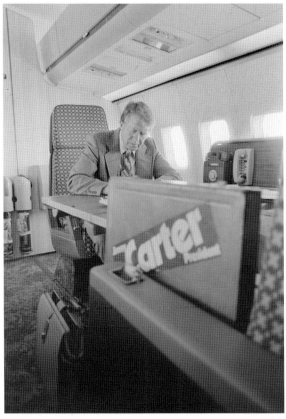

Zell Miller
Zell Miller served as mayor of his hometown, Young Harris, before serving in the Georgia state senate. He later served as lieutenant governor and the 79th governor of Georgia. Miller helped to establish a state lottery, the proceeds of which could be used to benefit schools. The lottery-funded HOPE (Helping Outstanding Pupils Educationally) Scholarship pays for four years of full in-state tuition and fees for students who graduate from high school with at least a 3.0 (B) average. (Courtesy of the United States Congress.)

Sam Massell
Sam Massell was Atlanta's first Jewish mayor and the youngest person to hold the office of mayor. He is credited with helping to establish the Metropolitan Area Rapid Transit Authority (MARTA) and for getting approval to build the Omni, the first enclosed arena in Atlanta. Massell left office to work in the travel and tourism industry. He is a member of the Georgia Hospitality Hall of Fame. (Courtesy of GSA.)

Sidney Marcus

Serving 15 years in the Georgia Legislature, Sidney Marcus was one of Atlanta's biggest advocates. He used his influence to offer financial support to the MARTA transit system, the Georgia World Congress Center, and Grady Memorial Hospital. A Jewish liberal, Marcus often battled his fellow legislators. He helped found the Urban Caucus, a coalition of legislators that supports bills beneficial to Atlanta. (Courtesy of AHC.)

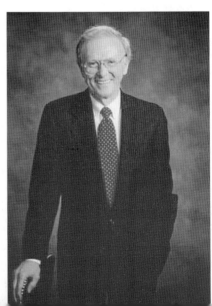

Paul Coverdell

When he ran for state senate, Paul Coverdell was president of his family's insurance company in Atlanta. After campaigning to elect George H.W. Bush president, Bush appointed Coverdell director of the Peace Corps. Coverdell returned home after two years and was elected US senator, establishing a reputation for being "a good and decent man." He died unexpectedly in his second term. The Peace Corps Headquarters are named in his honor. (Courtesy of the United States Congress.)

Max Cleland

Max Cleland lost both legs and his right forearm while serving in Vietnam. He received the Silver Star and the Bronze Star for valorous actions in combat. An advocate for veterans' affairs, Cleland served in the Georgia state senate before being appointed administrator of the US Veterans Administration under Pres. Jimmy Carter. Cleland was elected to the US Senate in 2002 and was appointed secretary of Veterans Affairs in the Clinton administration. (Courtesy of The Max Cleland Collection, duPont-Ball Library, Stetson University.)

Leah Ward Sears

Emory Law School graduate Leah Ward Sears became the first African American woman to serve as Superior Court judge in 1988. Gov. Zell Miller tapped Sears to become the first woman (and the youngest person ever) to sit on the Georgia Supreme Court in 1992. She was later elected Chief Justice of the Supreme Court of Georgia, the first African American to hold the prestigious position. (Courtesy of Leah Ward Sears.)

39

Shirley Franklin

Shirley Franklin was the first female mayor of Atlanta and the first African American woman to become mayor of a major Southern city. In 1978, she began working in Atlanta's city government as commissioner of Cultural Affairs under Mayor Maynard Jackson. Franklin's successful mayoral run in 2001 was her first campaign for public office. She slashed budgets, cut employees, and increased taxes in order to help balance the city budget. Franklin won a second term with a landslide 90 percent of the vote. She also helped repair the city's antiquated sewer system and worked to make Atlanta more "green" (environmentally friendly). Franklin earned national attention for her ability to get things accomplished despite budget deficits. (Courtesy of the City of Atlanta.)

CHAPTER THREE

The Visionaries

Atlanta has had more than its fair share of people whose dreams and ideas have helped to change the world. They are inventors, innovators, and true visionaries. They are people who took their ideas and made them a reality, thereby impacting countless others. It is actually quite amazing how many Atlanta-born ideas are now part of the fabric that affects people around the world.

One of Atlanta's earliest innovators was John Pemberton, the creator of Coca-Cola. Concocted in Atlanta, the brand is found in every country around the world. In addition, Ted Turner's 24-hour news channel started in Atlanta. The first satellite dishes of Cable News Network (CNN) went up just blocks from Georgia Tech. CNN now has a global audience. In the 1970s, Atlantans Dennis Hayes and Dale Heatherington changed the way computers "talk" to one another. Architects Philip Trammell Shutze and John Portman's designs are iconic not just in this city, but in cities throughout the United States and the world. The yellow glow of Tom Folkner and Tom Rogers's Waffle House sign was first seen in Atlanta.

Lesser known outside the Atlanta area are those who have impacted their community through their drive to change it. Not everyone knows Tim Singleton's name. He is a man who loved to run and helped to create the celebrated four-kilometer Peachtree Road Race, which brings runners Atlanta to each July.

This chapter celebrates both the names we readily know and those that are celebrated within their individual industries and communities. These are only some of Atlanta's many visionaries.

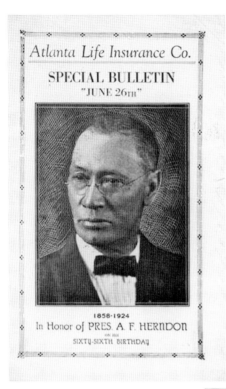

Atlanta Life Insurance Co.

SPECIAL BULLETIN
"JUNE 26TH"

1858-1924
In Honor of PRES. A. F. HERNDON
SIXTY-SIXTH BIRTHDAY

Alonzo Herndon

Alonzo Herndon was Atlanta's first African American millionaire. Born to a slave and her white master, he was emancipated as a child. Herndon had just one year of schooling when he opened a successful barbershop in Jonesboro, Georgia. As business expanded, Herndon began investing in real estate. He moved his family to Atlanta, where he established the Atlanta Life Insurance Company. The company grew to a multimillion-dollar enterprise with offices in seven states. (Courtesy of the Auburn Avenue Research Library.)

Philip Trammell Shutze

Philip Trammell Shutze completed his architectural certification at Georgia Tech in 1912. While his designs brought him international acclaim, some of his most iconic buildings are located in Atlanta. Among the most celebrated are the Swan House (now part of the Atlanta History Center) and the Academy of Medicine (located on West Peachtree). (Courtesy of AHC.)

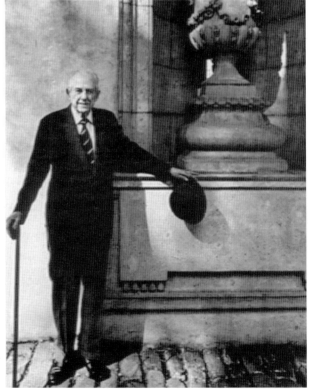

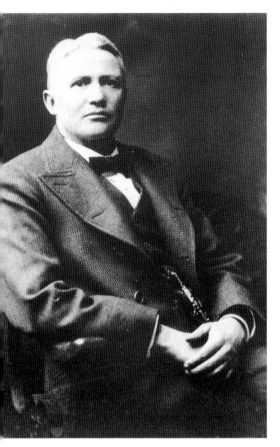

Amos Rhodes

In 1875, Amos Rhodes moved to Atlanta as a laborer for L&N Railroad. He opened a small furniture company that quickly grew, ultimately becoming the fourth-largest furniture store in the United States. Rhodes is credited with starting a program that allowed customers to buy furniture with installment payments. An avid traveler, Rhodes built the elaborate granite Rhodes Hall on Peachtree (which was based on German castles) in 1904. (Courtesy of the Georgia Trust for Historic Preservation.)

James J. Haverty

In 1885, J.J. Haverty and his brother Michael opened Havertys Furniture Company in downtown Atlanta. By 1889, he had partnered with Amos Rhodes in developing the Rhodes-Haverty Furniture Company. Although the business was thriving, Haverty went out on his own again and moved to Missouri. He returned to Atlanta in 1894. His company continued to expand, eventually becoming one of the top furniture retailers in the United States. (Courtesy of Havertys Furniture.)

Morris, Emanuel, and Daniel Rich
Morris Rich first opened a dry goods store at 36 Whitehall Street (now Peachtree Street) in 1867. By the time his brother Emmanuel joined him in business, M. Rich & Co. was the fifth-largest store in Atlanta and had moved to a much larger building. M. Rich and Brothers had more than doubled in size when his brother Daniel joined the firm. The Rich's prided themselves in catering to middle-class customers. Emmanuel Rich was personally involved in picking out many of the imported items, often bringing them back with him to avoid shipping costs. The company continued to grow steadily until, in 1929, it simply became known as "Rich's." One of the largest retail chains in the southeastern United States, the company remained family operated until it was sold to Federated Department Stores in 1976. (Left, courtesy of AHC; below, courtesy of McDonald.)

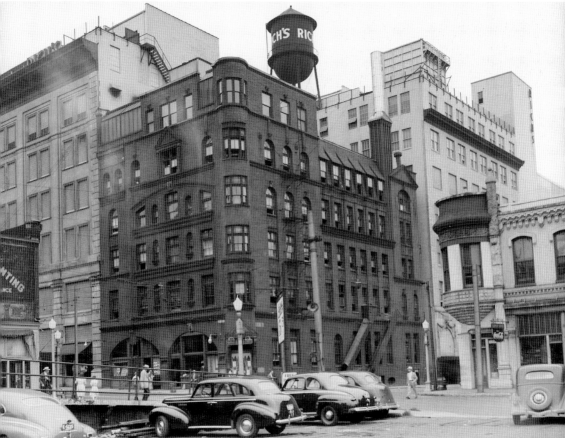

J. Neel Reid

Neel Reid's prolific architectural career was cut short by his death at the age of 40. Known predominantly for his residential designs, Reid's work was in demand throughout the southeastern United States. He designed many of the homes in the Ansley Historic District of Midtown. Reid was also responsible for Atlanta's Amtrak building and the Scottish Rite Hospital for Crippled Children in Oakhurst. (Courtesy of GSA.)

L.W. "Chip" Robert

L.W. "Chip" Roberts was a well-known Atlanta engineer and architect who was involved in numerous other ventures, including as president of the Atlanta Crackers minor league baseball team. He also served as assistant treasurer of the United States from 1933 to 1936. Having founded Georgia Tech's secret honor society known as ANAK, Roberts became the first recipient of its Alumni Distinguished Service Award in 1934. (Courtesy of Georgia Tech.)

John Pemberton

A Confederate veteran, Dr. John Pemberton sought to develop a drink that would help him to overcome the morphine addition he developed after being wounded. He was making coca wine when Fulton County enacted temperance legislation, forcing him to experiment with nonalcoholic drinks. He concocted syrup for a carbonated fountain drink and sold it under the name "Coca-Cola" for five cents a glass. Pemberton died before his cola became a commercial success. (Courtesy of LOC.)

Asa Candler

Asa Candler was manufacturing patent medicines when he purchased the formula for a tonic called Coca-Cola from a cash-strapped John Pemberton for just $550. Candler aggressively marketed the fountain drink and is credited with building The Coca-Cola Company into a multimillion-dollar business by the early 1900s. A philanthropist, Candler used his earnings in real estate and banking to help establish Emory University. He also gave millions to what would later become Emory Hospitals. (Courtesy of The Coca-Cola Company.)

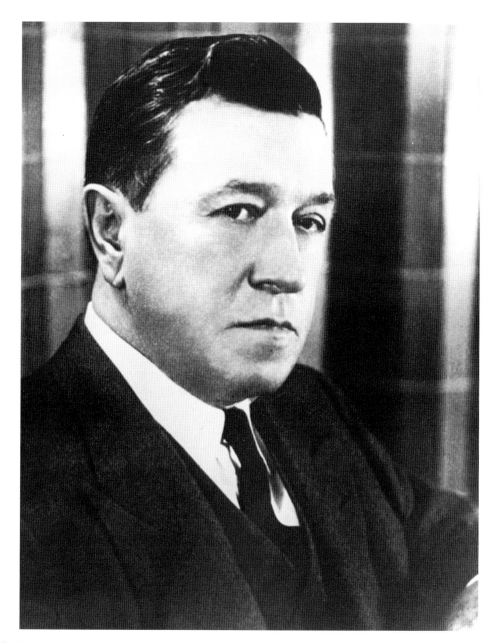

Robert Woodruff

Robert Woodruff was just 30 years old and working as general manager of the White Motor Company when his father, Ernest Woodruff, and a group of investors purchased The Coca-Cola Company from Asa Candler for $25 million. Within four years, the younger Woodruff was elected president of Coca-Cola and began what is widely recognized as a six-decade-long era of leadership and growth. In 1926, Woodruff established a foreign sales department, a move that propelled Coke into international markets and helped to establish it as one of the most recognized brand names in the world. Known for his philanthropy, Woodruff was a great supporter of education, health care, environmental efforts, culture, and the arts. He established the Robert W. Woodruff Foundation and the Woodruff Arts Center—Atlanta's largest cultural institution. (Courtesy of The Coca-Cola Company.)

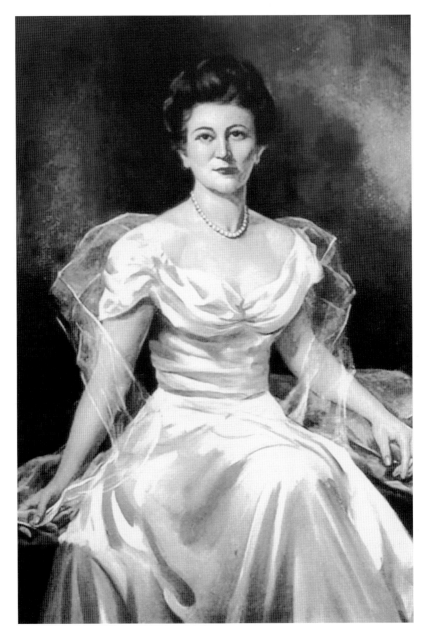

Lettie Pate Whitehead

Lettie Pate Whitehead served on the board of directors of Coca-Cola, one of the first women in the United States to hold such a position in a major corporation. Lettie and Robert Whitehead moved to Atlanta after Robert had negotiated the rights to start bottling Coca-Cola's new soft drink. Coke had previously only been sold at fountains. When Robert died in 1906 at the age of 42, Lettie took over the business, overseeing its expansion. She remarried Col. Arthur Evans and became involved in numerous philanthropic ventures, contributing to Scottish Rite Children's Hospital, Emory University, Agnes Scott College, Berry College, and the Tallulah Falls School. Internationally, she served on the board of the American Hospital in Paris and the Queen's Fund for air raid victims of World War II in England. (Courtesy of The Lettie Pate Whitehead Foundation.)

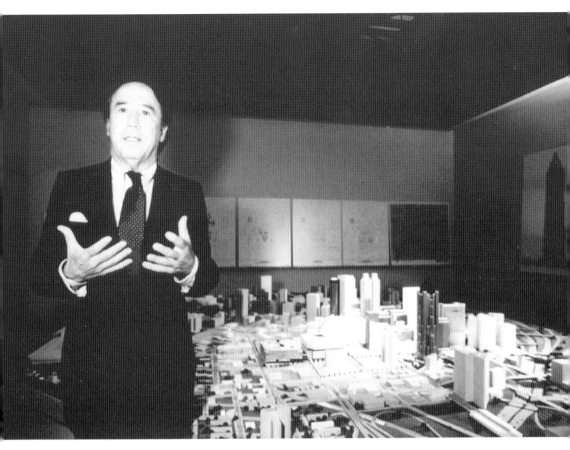

John Portman

Downtown Atlanta's skyline is largely attributed to the vision of architect John Portman. His commercial designs utilizing open multistoried atria helped reshape how modern hotels and office buildings were built, both in Atlanta and across the globe. Among his most iconic Atlanta buildings are the 73-story cylindrical Peachtree Plaza Hotel, The Hyatt Regency, the Atlanta Merchandize Mart, and the Marriott Marquis. The Peachtree Center Office Building, built in 1965, was a model for multi-use office buildings. A graduate of Georgia Tech, Portman has given other cities some of their most recognized structures, including the Renaissance Center in Detroit, the Embarcadero Center in San Francisco, Marina Square in Singapore, and Shanghai Centre. His buildings are found around the world, including numerous developments in Asia. (Courtesy of Georgia Tech.)

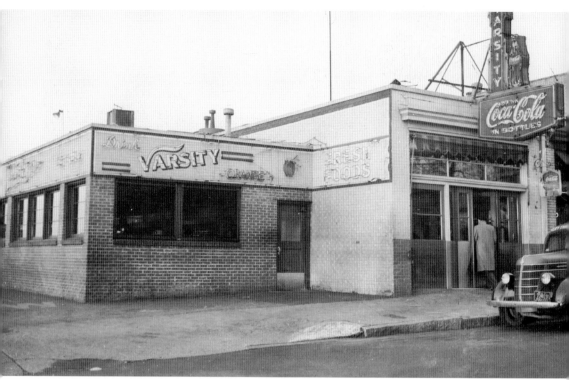

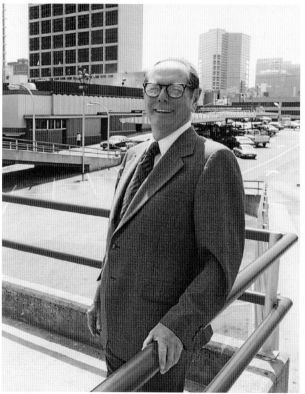

Frank Gordy

Frank Gordy revolutionized the fast-food business. In 1927, he opened his first restaurant across from Georgia Tech, a simple hotdog stand called the Yellow Jacket. Having worked in his uncle's peach packing plant, Gordy began applying an assembly-line mentality toward getting his food out fast, fresh, and hot. Gordy quickly outgrew the Yellow Jacket and opened The Varsity just up the street in 1929. The term "car hop" was created after he recruited neighborhood kids to take orders by hopping onto a car's running board as it entered the parking lot. By the 1950s, his restaurant had become the largest drive-in in the world, and businessmen from across the globe would come to study how he was able to succeed with such turnover. An Atlanta landmark, the order taker's cry of "What'll ya have" is a mantra for many Atlantans. (Courtesy of The Varsity.)

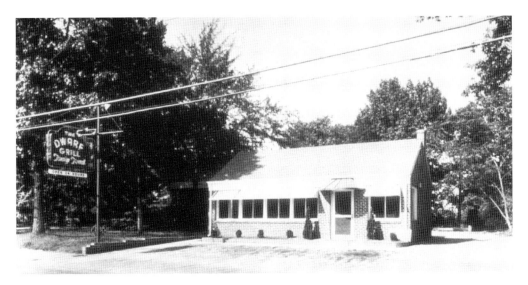

Truett Cathy

Truett Cathy is credited with inventing Chick-fil-A's boneless breast of chicken sandwich. Cathy's first restaurant, which opened in 1946 in Hapeville, Georgia, was originally called the Dwarf Grill because of its size. There were just four tables and 10 stools at the counter. Cathy later renamed the restaurant The Dwarf House, and it was here in the 1960s that he developed the recipe for his boneless breast of chicken sandwich that would ultimately become the signature menu item of the Chick-fil-A restaurant chain. The first Chick-fil-A restaurant opened in 1967 in Atlanta's Greenbriar Shopping Center. Dating back to his original restaurant and continuing today, all Chick-fil-A restaurants nationwide close on Sunday. Truett Cathy has also been involved in a number of philanthropic causes, such as offering a scholarship program for restaurant team members, establishing foster homes, and creating summer camps for children. (Courtesy of Chick-fil-A.)

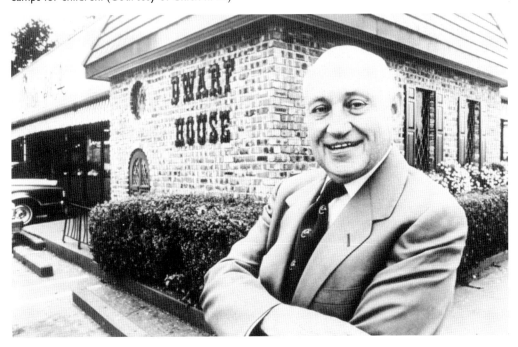

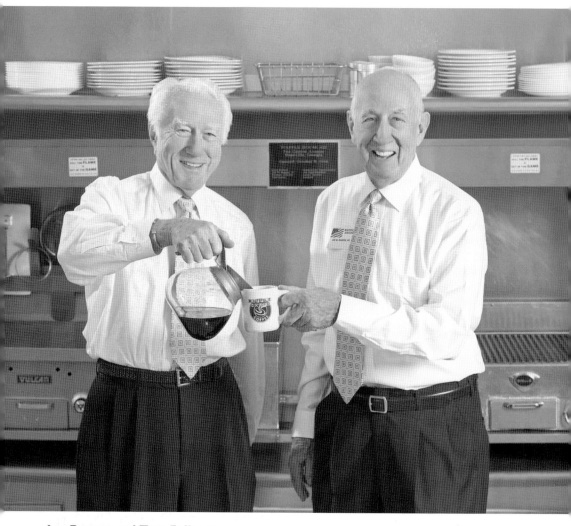

Joe Rogers and Tom Folkner
Joe Rogers (left) and Tom Folkner were neighbors when they decided they wanted to go into business together. They opted to create a restaurant that would attract everyday people. In 1955, the first Waffle House opened in Avondale Estates. Within a few years, the motto of "Good Food, Fast" sparked a demand for more, and two more opened, then four, then more. Soon, Waffle House had expanded throughout Georgia and into neighboring states. The iconic yellow sign of the Waffle House now shines in 48 states, serving food "24 hours a day, 365 days of the year." Each features a jukebox of Waffle House songs. Waffle House avoids advertising, instead choosing to attract customers by reputation and word of mouth. (Courtesy of Waffle House.)

Sydell Harris

Sydell Harris taught Atlantans how to pamper themselves. A trained esthetician, she opened her first day spa in 1982. Spa Sydell was quickly recognized as a place for rejuvenation and, at one point, had eight locations around the Atlanta area. Harris's anti-aging skin care products gained national recognition. This 1997 photograph shows Harris during an appearance on NBC's *Today Show* with Katie Couric. (Courtesy of Sydell Harris.)

Anne Cox Chambers

Media mogul and philanthropist Anne Cox Chambers is known for her ability to get things done quietly. In 1898, her father founded Cox Enterprises, which grew to include television stations, newspapers, and other publications across the United States. Even though she is listed as one of the richest women in America, Cox Chambers prefers that her contributions take place outside of the public eye. Among her causes are the High Museum of Art, the Atlanta Symphony Orchestra, the Fernbank Museum of Natural History, and the Shepherd Center. (Courtesy of Cox Enterprises.)

Ted Turner (OPPOSITE PAGE AND BELOW)

Robert Edward "Ted" Turner III began his career working for his family's advertising company, Turner Advertising. In 1963, after his father's death, 24-year-old Ted took the helm. He transformed the company into a successful business and began building a media empire. Turner is credited with revolutionizing the cable industry by creating channels such as the SuperStation (WTBS), Cartoon Network, Turner Network Television (TNT), Turner Classic Movies (TCM), and, most notably, the Cable News Network (CNN)—the world's first live 24-hour global news network.

In 1996, Turner Broadcasting System, Inc. merged with Time Warner, Inc. (which purchased by America Online in 2001, thus becoming AOL Time Warner). The AOL merger quickly proved detrimental to the company as a whole. Turner resigned as vice chairman of AOL Time Warner in 2003 and left the board entirely in 2006.

Turner made his mark in the sports world as well. In the mid-1970s, Turner purchased the Atlanta Hawks basketball team and the Atlanta Braves baseball team. The Atlanta Braves went from "worst to first" in the National League East division and won the 1995 World Series. Turner is also an accomplished sailor, having won—among many other awards—the coveted America's Cup in 1977. He was inducted into the National Sailing Hall of Fame in 2011. A devoted philanthropist, Turner champions numerous environmental causes across the globe through his family foundation, the Turner Foundation. In 1997, he pledged $1 billion to support United Nations causes, later forming the United Nations Foundation. Turner also lends support through his other foundations—the Turner Endangered Species Fund, the Captain Planet Foundation, and the Nuclear Threat Initiative.

In 2002, Turner cofounded the national restaurant chain Ted's Montana Grill with restaurateur George McKerrow Jr. Currently operating 44 locations nationwide, Ted's Montana Grill—a classic American grill—is noted for featuring bison on its menu, many of which are raised on Turner's own ranches. Turner is the owner of the largest commercial bison herd (55,000) in North America and is the second-largest private landowner, with over two million acres in the United States and Argentina. (Courtesy of the Turner Foundation.)

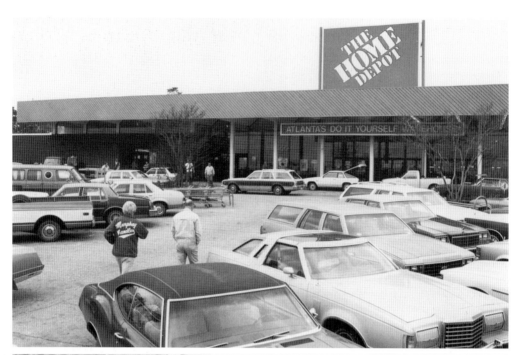

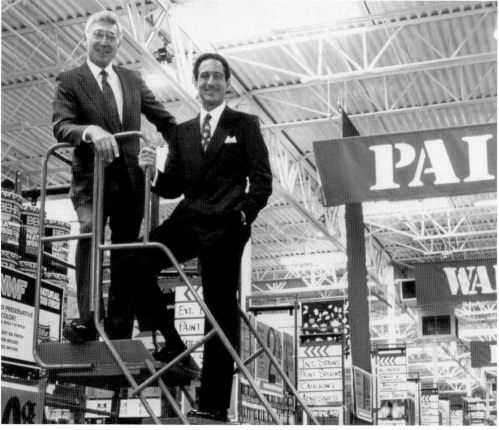

Arthur Blank and Bernie Marcus

(OPPOSITE PAGE AND RIGHT) When Arthur Blank (right in the bottom left photograph) and Bernie Marcus were fired as officers of a Southern California home center chain, they opted not to look for new jobs. Instead, they started their own company, the result of which is the Home Depot— the largest home improvement retailer in the United States.

Blank and Marcus had been working on a plan to reorganize their old employer. Their idea was to take the convenience and service one might find in small hardware stores and to combine it with the low prices and huge selection found in warehouse outlets. In 1978, they set up shop in two vacant storefronts in suburban Atlanta, stocking the shelves with more than 18,000 items, ranging from lighting fixtures to plumbing and paint. They personally hired and trained their staff, and their gamble paid off. Two years later, they opened two more stores in Miami. As word spread, so did the success of The Home Depot.

Upon retiring from the company, they set out to pursue both philanthropic interests and their own passions. In 2005, Marcus and his wife, Billie, contributed more than $250 million dollars to create the Georgia Aquarium, which was the largest in the world at the time. He also founded The Marcus Institute, which provides services for developmentally disabled children and adolescents. Blank sits on the board of numerous charities, including the Arthur Blank Foundation. He also owns the Atlanta Falcons football team. (Courtesy of The Home Depot.)

Mills B. Lane
Under Mills B. Lane, the Atlanta-based Citizen and Southern Bank (C&S) grew to be the largest bank in the South. Working with Mayor Ivan Allen Jr., Lane helped to ease racial tensions in the 1950s and 1960s by promoting dialogue between blacks and whites. By funding and building Atlanta's Fulton County Stadium, Lane was key in bringing the Falcons football and Braves baseball teams to Atlanta. The Braves made the move based on a handshake deal between Lane and their Milwaukee owners. (Courtesy of Georgia State University.)

J.B. Fuqua
Although J.B. Fuqua grew up on a small tobacco farm in Virginia, he was able to transform his interest in radio and television into a large and successful media empire. Active in Georgia politics, he served in both the House and the Senate, even chairing the Georgia Democratic Party 1962–1966. A noted philanthropist, Fuqua established The Dorothy Chapman Fuqua Conservatory at the Atlanta Botanical Garden in honor of his wife. (Courtesy of Duke University.)

Tom Cousins
As the head of Cousins Properties, Tom Cousin led the way for such notable Atlanta landmarks as the CNN Center, the Omni Coliseum, and the Bank of America Plaza. He was also instrumental in revitalizing the historic East Lake Golf Course, including restoring golfing-great Bobby Jones's home and redesigning the course. A noted philanthropist, Cousins partnered with Warren Buffet to create the Purpose Built Communities organization to help revitalize communities. (Courtesy of Jennifer Stalcup.)

Tim Singleton
An avid runner and the cross-country coach for Georgia State University, Tim Singleton came up with the idea to hold a road race in Atlanta each year on the Fourth of July. The first race in 1970 drew just 100 runners, but the idea caught on. The Peachtree Road race is a 10-kilometer race that now attracts more than 60,000 runners to Atlanta each year. (Courtesy of Austin Holt.)

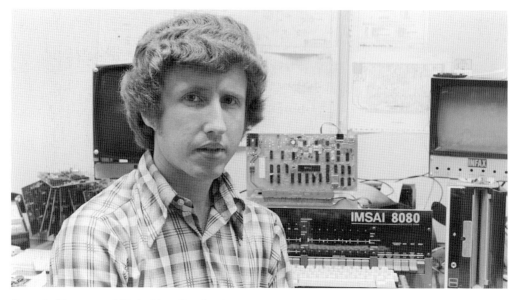

Dennis Hayes and Dale Heatherington

By creating the first personal computer modem, Dennis Hayes and Dale Heatherington helped to transform modern communication and how the internet is used. The two met while working at National Data Corporation and soon formed their own company. They pooled funds to buy an IMSAI 8080 computer kit and then drew out (on a napkin) a way to allow microcomputers to communicate with other computers through telephone lines. The 80-103A PC modem was created in 1977, and Hayes Microcomputer Products developed into a powerhouse in the computer industry. Above, Dennis Heatherington sits in front of an IMSAI 8080 computer and an early 300-baud Hayes modem. Below, Glenn Sirkis, Dave Lankshear, and Dennis Hayes are shown working on their modems. (Courtesy of Dale Heatherington.)

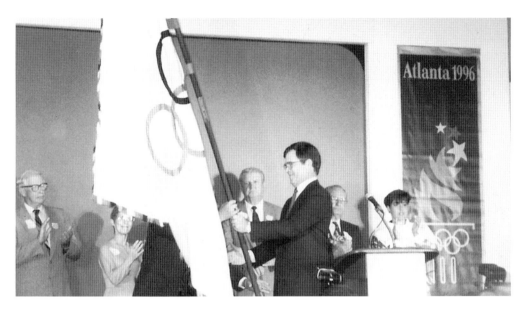

Billy Payne

In 1987, Billy Payne was a lawyer and real estate investor when he got the idea that Atlanta should host the 1996 Olympic Games. He recruited Mayor Andrew Young to his cause and soon had numerous area business leaders behind his bid. In September 1990, the International Olympic Committee selected Atlanta to host their 1996 Centennial Games. After leading the mid effort, Payne stayed on to head the Atlanta Olympic Committee through the completion of the games, the first bid organizer to do so. Above, Billy Payne accepts the Olympic flag on behalf of the Atlanta Olympic Committee. Below, the agreement is being signed that made WGST "Atlanta's official Olympic information radio station." Pictured from left to right are (first row) Bob Houghton; Billy Payne; Eric Seidel; A.D. Frazier; (second row) Joe Bankoff of King and Spalding; Nancy Zintak; Ed Hula; and Steve Youlios, WGST general sales manager. (Courtesy of Around the Rings.)

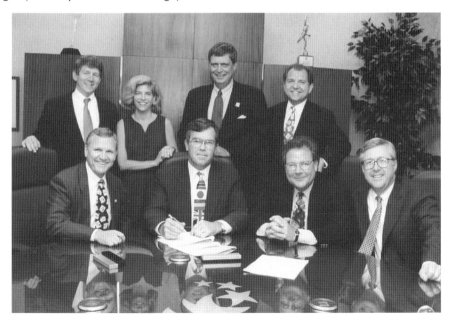

Ed McBrayer

Ed McBrayer was a leading force behind the PATH Foundation, a nonprofit organization whose mission is to build a network of greenway trails for cycling and walking in Atlanta. The move began ahead of the 1996 Atlanta Olympic Games. Within 20 years, PATH had developed almost 200 miles of trails around Metro Atlanta and surrounding counties. (Courtesy of PATH.)

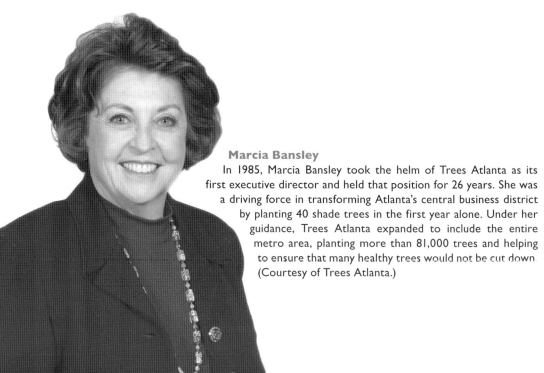

Marcia Bansley

In 1985, Marcia Bansley took the helm of Trees Atlanta as its first executive director and held that position for 26 years. She was a driving force in transforming Atlanta's central business district by planting 40 shade trees in the first year alone. Under her guidance, Trees Atlanta expanded to include the entire metro area, planting more than 81,000 trees and helping to ensure that many healthy trees would not be cut down (Courtesy of Trees Atlanta.)

Bill Bolling
In 1979, Bill Bolling founded the Atlanta Community Food Bank and has continued to serve as executive director ever since. Conceived to feed Atlanta's hungry, the organization now distributes 45 million pounds of food and groceries each year. The network has grown to serve 29 Georgia counties through 600 local and regional nonprofit partners. Bolling also helped found Feeding America, a national network of food banks. (Courtesy of the Atlanta Community Food Bank.)

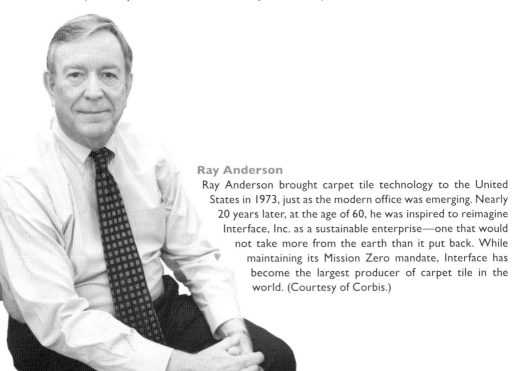

Ray Anderson
Ray Anderson brought carpet tile technology to the United States in 1973, just as the modern office was emerging. Nearly 20 years later, at the age of 60, he was inspired to reimagine Interface, Inc. as a sustainable enterprise—one that would not take more from the earth than it put back. While maintaining its Mission Zero mandate, Interface has become the largest producer of carpet tile in the world. (Courtesy of Corbis.)

Sara Blakely

Sara Blakely was a sales trainer by day and standup comedian by night when she cut the feet out of pantyhose to give her a better shape while wearing white pants. Blakely knew other women would love these footless pantyhose, but hosiery manufacturers scoffed at her idea. However, one lone company took a chance on Blakely's idea. The result is SPANX, a billion-dollar company that helps women and men flatter their shapes with a variety of garment options. (Courtesy of SPANX.)

Alex Cooley

After staging the first Atlanta International Pop Festival in 1969, Alex Cooley went on to be one of the top music promoters in the United States. Most musicians aspired to have "Alex Cooley Presents" printed on their tickets and advertisements. In 1994, Cooley helped establish Music Midtown, which featured the likes of James Brown, Al Green, and Joan Baez. In 2011, Cooley bought Decatur's popular music venue Eddie's Attic. (Courtesy of David Woolf.)

CHAPTER FOUR

Civil Rights

Atlanta was indisputably at the center of the civil rights movement of the 1950s and 1960s, but the efforts to establish equality among the races and sexes started in the city long before. Following the Civil War, Atlanta was a city where African Americans were able to establish businesses and be leaders of their community, albeit segregated at the time.

Atlanta had a thriving black community by the time W.E.B. Du Bois made his way to Atlanta. His call for civil rights was heard nationally and internationally, starting a movement to help win rights for not just African Americans, but all people he felt were disenfranchised. Voter's rights became a key issue, and people like John Wesley Dobbs and Clarence Bacote fought to register black voters. By the time Dr. Martin Luther King Jr. began preaching his message of change without violence, Atlanta was well ahead of the rest of the country in the effort to establish civil rights for all.

Mayor Ivan Allen Jr. would say, in the 1950s and 1960s, that Atlanta was the city too busy to hate. While there were times when that statement was not true, the city set a shining example for the rest of the country. By the time King was assassinated, the movement had a momentum that was virtually unstoppable.

Many of those involved in the civil rights movement remained in Atlanta and continued their commitment to help better others. Many—like Hosea Williams, Xernona Clayton, Joseph Lowery, Andrew Young, and Julian Bond—have worked to effect change through political and service organizations, while others, like John Lewis, went on to hold national offices.

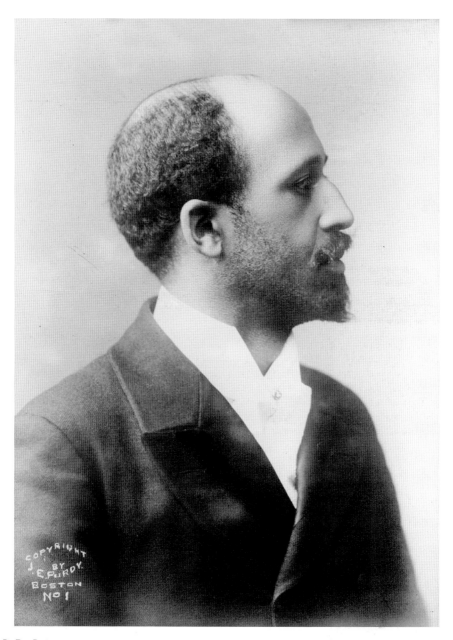

W.E.B. Du Bois
William Edward Burghardt "W.E.B." Du Bois was arguably one of the country's first civil rights leaders. Born in 1868 in Massachusetts, he grew up in a relatively tolerant community and attended Harvard University. He became the first African American to earn a doctorate. Du Bois moved to Atlanta to teach history, sociology, and economics at Atlanta University. He campaign widely for civil rights and education and wrote numerous papers about the African American workforce and culture. During his day, Du Bois and Booker T. Washington were considered the spokespeople for African Americans. In 1909, Du Bois helped cofound the National Association for the Advancement of Colored People (NAACP). It was Du Bois who suggested using the term "colored" rather than "black," so that "dark skinned people everywhere" would be included. (Courtesy of LOC.)

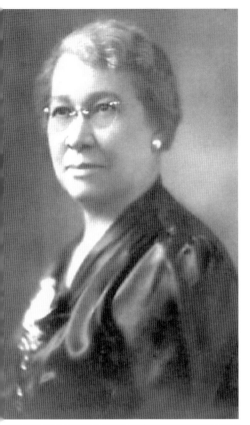

Lugenia Burns Hope
In the late 1800s, Lugenia Burns Hope, known as "The First Lady of Morehouse," recruited students from her husband John Hope's college to go door-to-door to gather the challenges facing local families. She then set out to improve them. Hope organized the Neighborhood Union to provide services, such as daycare and recreational facilities, which were not being offered to blacks by government entities. She also fought against discrimination in education. (Courtesy of GSA.)

John Wesley Dobbs
An Atlanta native, John Wesley Dobbs was often referred to as the unofficial mayor of Auburn Avenue. An ardent proponent of voter's rights and equality in education, he founded the Georgia Voters League in 1935 and the Atlanta Civic and Political League. Between 1936 and 1945, he was able to register more than 20,000 black voters in Atlanta. Atlanta's schools desegregated the week that he died (in 1961). (Courtesy of the Amistad Research Center.)

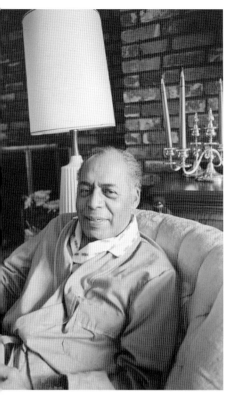

Clarence Bacote
A historian and scholar, Clarence Bacote dedicated his life to registering the black voters of Atlanta. He was member of the history faculty at Atlanta University for 47 years. Working with the NAACP, he helped to educate blacks about how government works and the importance of voting. Bacote also helped create the Atlanta All-Citizens Registration Committee and served as its chair. He later chaired the Atlanta Negro Voters League. (Courtesy of AHC.)

Benjamin Burdell Beamon
A restaurateur, promoter, and entertainer, "B.B." Beamon ran the Magnolia Ballroom restaurant and hotel, which became a key meeting place for members of the civil rights movement. The bylaws of the Student Non-Violent Coordinating Committee were written in the restaurant. In addition to starting a dance studio in the 1950s (the Academy of Ballet Arts), Beamon also owned the Savoy Hotel and the popular B.B. Beamon's Cafe on Auburn Avenue. Edna McGriff is shown (left) with Beamon. (Auburn Avenue.)

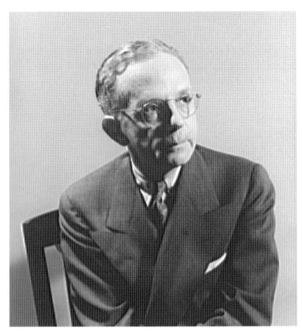

Walter White

Born into a prominent black Atlanta family, Walter White helped found the Atlanta branch of the NAACP. His fair complexion allowed him to work undercover investigating lynching and race riots. His book *Rope and Faggot* is considered the authoritative analysis on lynching. White campaigned against discrimination on a national and international level. He served as the NAACP's chief secretary from 1929 to 1955. (Courtesy of LOC.)

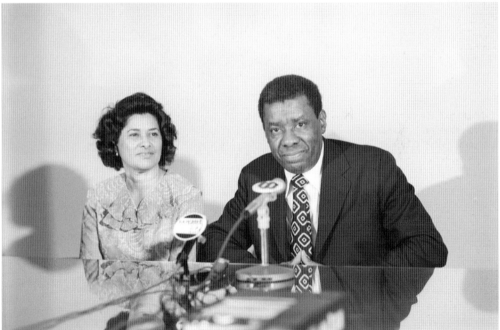

Jesse Hill

A business leader and activist, Jesse Hill was the chief executive officer of Atlanta Life Insurance Company after Alonzo Herndon retired. Hill joined the NAACP and encouraged black students to challenge the segregation of Georgia's colleges, successfully getting Hamilton Holmes and Charlayne Hunter enrolled at the University of Georgia in 1961. Hill became chairman of the Atlanta Area Chamber of Commerce in 1977, the first African American to hold such a position. His wife, Azira Hill, is to his left. (Courtesy of AHC.)

Dr. Martin Luther King Jr.

Dr. Martin Luther King Jr. was the clear leader of the civil rights movement in the 1950s and 1960s. King was born in Atlanta, where his father and grandfather both served as the pastors of Ebenezer Baptist Church. King attended Morehouse University and then graduate school at Boston University. By the time he became pastor of Dexter Avenue Baptist Church in Montgomery, Alabama, he was gaining attention for being an outspoken proponent of civil rights, and his role as a leader was becoming readily obvious. In 1955, King was on the executive board of the NAACP when he led the first of many nonviolent demonstrations. This particular demonstration was aimed at interstate bus service, with the goal to have blacks and whites be able to ride the same bus without segregated seating.

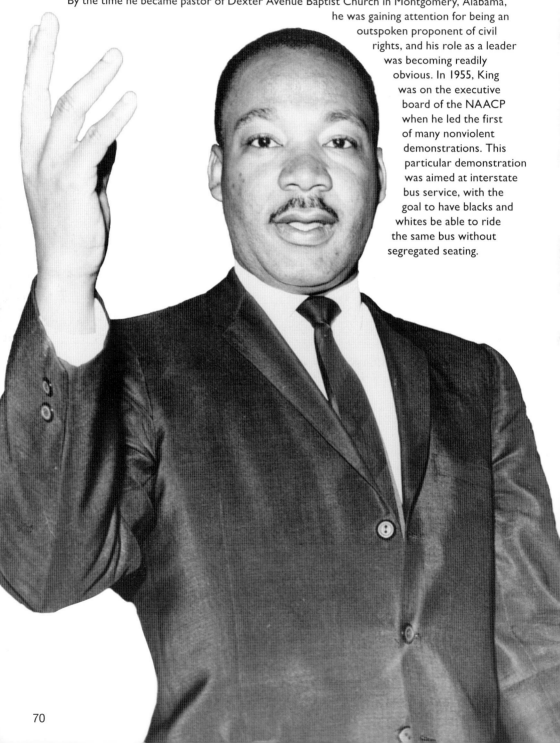

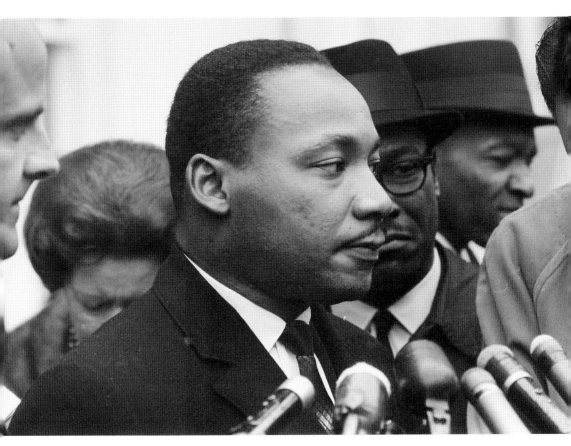

By the time King was elected president of the Southern Christian Leadership Conference, the civil rights movement had grown to be a force to be reckoned with. The 1963 March on Washington for Jobs and Freedom was considered a turning point. Almost 300,000 people turned out on the National Mall. It was here that King delivered his celebrated "I Have a Dream" speech. In 1964, Congress passed the Civil Rights Act. That same year, King was award the Nobel Peace Prize for his unwavering commitment to exact change through nonviolent methods.

King continued to organize marches while expanding his focus toward the countering of the Vietnam War and poverty. In 1968, while working on the Poor People's Campaign in Memphis, Tennessee, King was assassinated. Following his death, his widow, Coretta Scott King, established the Martin Luther King Jr. Center for Nonviolent Social Change in Atlanta, which continues to work on national and international initiatives. (Both, courtesy of LOC.)

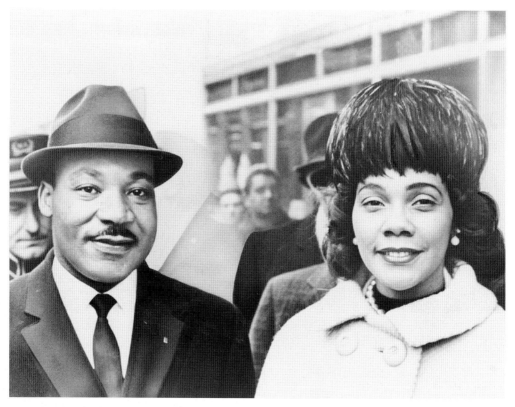

Coretta Scott King

Coretta Scott King was considered the first lady of the civil rights movement. Married to Martin Luther King Jr., she took an active role in the move to exact change. While raising four children, she participated in many of the movement's marches, most notably the Montgomery bus boycott of 1955. She was instrumental in constructing the Civil Rights Act of 1964. Following her husband's death, Scott King founded the Martin Luther King Center for Nonviolent Social Change to help continue his work. She began campaigning for women's rights, as well as for rights for the gay community. She also became involved in the campaign against apartheid in South Africa. She continued to speak out against injustices including capital punishment. The photograph below shows Dexter King on the left of Coretta Scott King and Bernice and Yolanda King on her right. (Top, courtesy of LOC; below, courtesy of Tom Houck.)

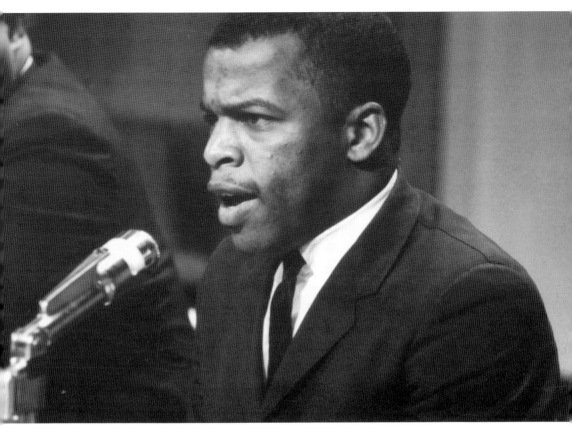

John Lewis

John Lewis joined the civil rights movement as a Freedom Rider in 1961. He was one in a group of activists that defied segregation in bus terminals across the South, often being beaten and jailed for his efforts. With fellow activist Julian Bond, Lewis helped form the Student Nonviolent Coordinating Committee, which organized students to conduct sit-ins, marches, and other activities on behalf of civil rights. In 1963, Lewis was, at the age of 23, a keynote speaker during the March on Washington. He was considered to be one of the "Big Six" of the civil rights movement, along with Whitney Young, Philip Randolph, Martin Luther King Jr., James Farmer, and Roy Wilkins. Lewis was elected to the Atlanta City Council in 1981 and then to the US House of Representatives, where he continues to serve. He remains committed to the civil rights cause. (Courtesy of LOC.)

Andrew Young

Andrew Young moved to Atlanta to work with the Southern Christian Leadership Conference (SCLC), teaching workshops in nonviolent strategies and helping with voter registration. He helped lead numerous desegregation campaigns across the South, eventually rising to become executive director of the SCLC. Young became a trusted aide of Dr. Martin Luther King Jr. and was on the balcony with King in Memphis when King was killed. He continued his activism after King's death and was elected to the US House of Representatives in 1973. Under Pres. Jimmy Carter, Young served as ambassador to the United Nations. He was elected mayor of the city of Atlanta in 1982 and was instrumental in the city winning its bid to host the 1996 Olympic Games. In the photograph below, an unidentified woman speaks with King (center) and Young (right). (Right, courtesy of LOC; below, courtesy of Emory University.)

Hosea Williams

Hosea Williams first gained national recognition by marching alongside Dr. Martin Luther King Jr. He was standing on the balcony next to King when King was assassinated in 1968 in Memphis, Tennessee. The ordained minister vowed to continue King's work of looking after the poor and, in doing so, founded Hosea Feed the Hungry and the Homeless, one of the largest social service organizations for the poor and hungry in North America.

A true legend, Williams had served as an Army staff sergeant in World War II under Gen. George S. Patton. The only survivor of a Nazi attack, he was awarded a Purple Heart and, after more than a year in a European hospital, returned to Atlanta to earn his high school diploma at the age of 23. Williams attended Morris Brown College and Atlanta University, eventually becoming a research scientist for the US Department of Agriculture.

After drinking from a "Whites Only" water fountain, Williams was beaten and left for dead. Upon recovering, he joined the NAACP and began working with King and other leaders of the Southern Christian Leadership Conference (SCLC) to fight for civil rights. He suffered numerous beatings as he led marches between the 1960s and the 1980s. Williams served as the head of the SCLC and was actively involved in politics, serving on the Atlanta City Council, the DeKalb County Commission, and the Georgia General Assembly. (Courtesy of AHC.)

Joseph Lowery

Rev. Joseph Lowery was pastor of the Warren Street United Methodist Church in Mobile, Alabama, when he launched a drive to stop discrimination and segregation. He joined forces with Dr. Martin Luther King and Rev. Ralph David Abernathy to form the Southern Christian Leadership Conference in 1957. Lowery delivered sermons and speeches on the importance of civil rights and advocated exacting change through nonviolent methods. He moved to Atlanta to head the Central Church of Atlanta. That same year, King was assassinated and Lowery took over as the SCLC's chairman. Considered a moderate voice, Lowery campaigned for human rights and gained international acclaim for speaking out against South Africa's apartheid. Even after retiring, Lowery remained a committed activist for civil rights. Pres. Barack Obama had Lowery deliver the benediction at his 2009 inauguration. (Courtesy of AHC.)

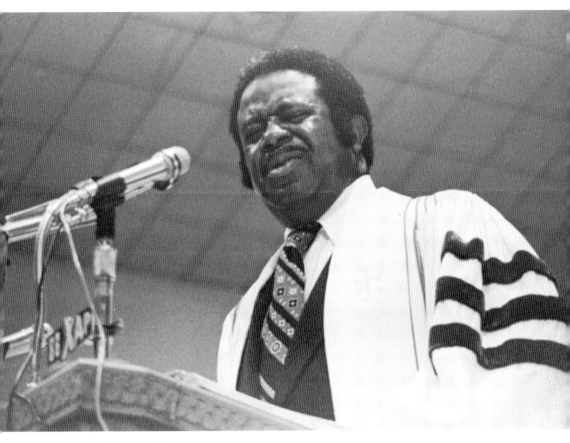

Ralph David Abernathy

Rev. Ralph David Abernathy was one of Dr. Martin Luther King's closet friends throughout the growth of the civil rights movement. Abernathy helped King organize boycotts and marches throughout the South. They were arrested together 17 times while promoting nonviolent methods for obtaining civil rights. The two joined forces with Rev. Joseph Lowery of the Southern Christian Leadership Conference. Considered King's right hand man during the height of the civil rights movement, King tapped Abernathy to be his successor. Following King's death, Abernathy took over the presidency of the SCLC and served on the board of directors of the Martin Luther King Jr. Center for Nonviolent Social Change. Before his death in 1990, Abernathy traveled the nation and the world giving addresses about the importance of peace. (Courtesy of AHC.)

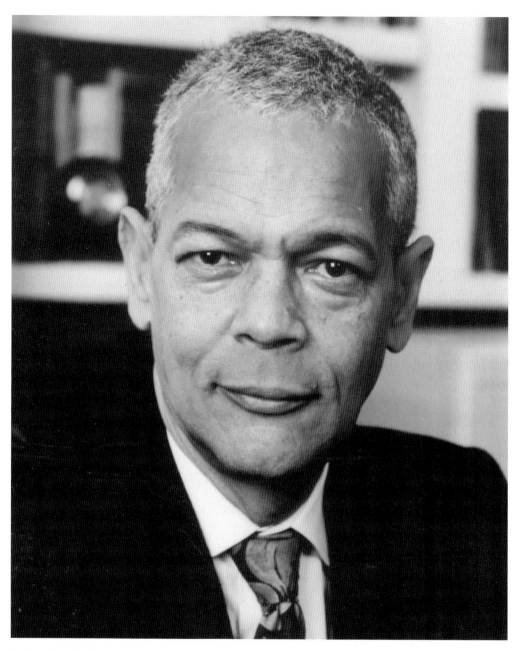

Julian Bond

Julian Bond was a student at Morehouse College when he became involved in the civil rights movement. He founded the Student Nonviolent Coordinating Committee, leading protests against segregation in Georgia. Bond was elected to the Georgia House of Representatives in 1965, but a year later, the House refused to seat him because of his support of the SNCC's stance against Vietnam. Bond won a Supreme Court ruling and regained his seat, serving in the Georgia House eight terms. He helped found the Southern Poverty Law Center with Morris Dees and served as its first president. In 1998, Bond took the helm of the NAACP and led it for 12 years. His commitment to civil rights made him an outspoken supporter of rights for gays and lesbians. (Courtesy of Julian Bond.)

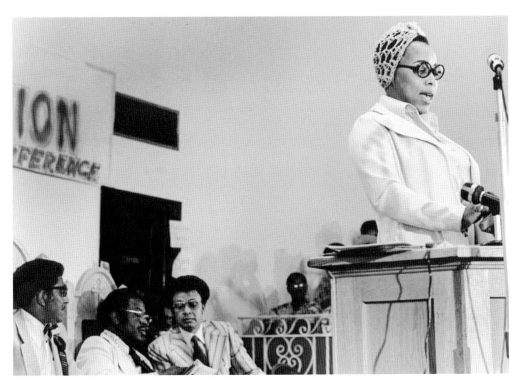

Dorothy Cotton

Dorothy Cotton was the highest-ranking female in the Southern Christian Leadership Conference, serving as the SCLC's education director from 1960 to 1968. After the death of Dr. Martin Luther King, Cotton became vice president for field operations for the Martin Luther King Jr. Center for Nonviolent Social Change. She continues to speak out for nonviolence and social change, traveling both nationally and internationally for civil rights issues. (Courtesy of AHC.)

Whitney Young

Whitney Young became involved with the National Urban League (NUL) while living in Nebraska. After moving to Atlanta to become dean of social work at Atlanta University, Young rose to become executive director of the National Urban League and, later, its president. He is credited for changing the relatively passive organization, into one that aggressively fought to break the barriers of desegregation and for social change. (Courtesy of LOC.)

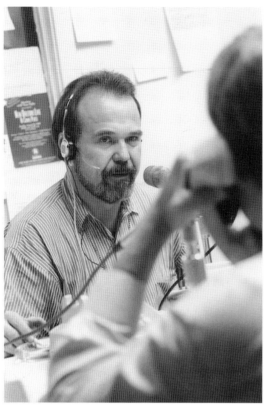

Tom Houck

Tom Houck moved to Atlanta as a teenager to get involved in the civil rights movement. He became a driver/chauffeur for Dr. Martin Luther King and, eventually, King's personal aide. Following Dr. King's assassination, Houck worked as the youngest member of the Southern Christian Leadership Conference's executive staff, helping to organize marches and rallies aimed at ending the Vietnam War. Working with John Lewis, he served as field director of the Voter Education Project, which sought to get minority voters involved in elections. Houck had his own talk show on NewsRadio WGST for almost 20 years and was a founding member of the National Association of Talk Show Hosts, which advocates the rights of journalists to First Amendment rights of free speech. Houck continues to be involved in both local and national political issues. Shown in the photograph below are US senator Wyche Fowler (left), Houck (center), and Julian Bond. (Courtesy of Tom Houck.)

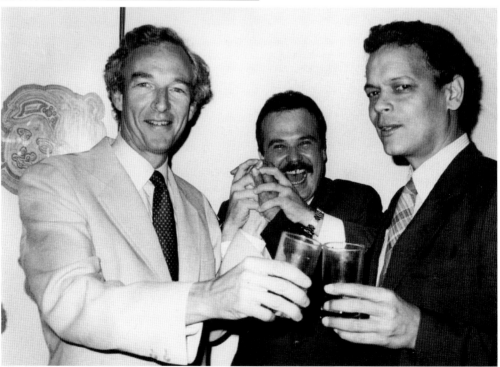

Fred C. Bennett
Fred Bennett started organizing protests against segregation while a student at Morehouse College in the 1950s. Reverend Bennett joined the Southern Christian Leadership Conference, becoming one of Dr. Martin Luther King's closet aides. A primary duty for Bennett was recruiting other pastors to join the cause. He ran the SCLC's Voter Registration project and served as deputy director of the Georgia Voters League. Bennett later served on Andrew Young's congressional staff. (Courtesy of AHC.)

Xernona Clayton
In 1965, Xernona Clayton moved to Atlanta to work with the Southern Christian Leadership Conference and Dr. Martin Luther King Jr. She broke barriers in 1967 as the first black host of a prime-time television show in the South. Clayton's dedication to racial understanding made her a constant presence in the Atlanta community. As vice president of urban affairs for Turner Broadcasting, she founded the Trumpet Awards Foundation to herald achievements of African Americans. (Courtesy of Xernona Clayton.)

Tom Offenburger

Tom Offenburger left his job as Southern bureau chief of *U.S. News & World Report* to become spokesman for Dr. Martin Luther King Jr. After King's death, Offenburger worked with Ralph David Abernathy at the SCLC and assisted Coretta Scott King in developing the King Center. He joined forces with Andrew Young when Young ran for Congress. Offenburger is shown here welcoming Abernathy to Young's congressional office in Washington, DC. (Courtesy of AHC.)

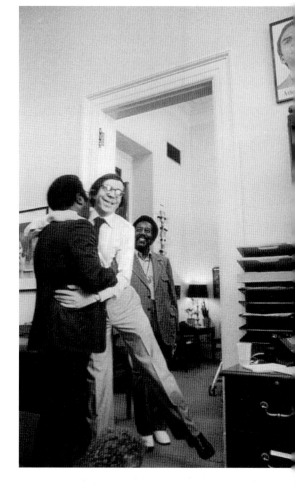

E.J. Shepherd

E.J. Shepherd was a popular restaurateur and a Georgia state representative. His restaurant, Shepherd's Home Cooked Foods, was a popular gathering spot for politicians, and he routinely held fundraising dinners for candidates of both races and organized church support for Dr. King's civil rights activities. Dr. King would routinely walk around the corner with his family to Shepherd's for Sunday lunch after preaching at Ebenezer Baptist Church. (Courtesy of AHC.)

Cecil Alexander

An outspoken proponent of civil rights, Cecil Alexander was one of Atlanta's premier architects during the late 21st century. In the 1950s–1960s, he supported Dr. Martin Luther King, speaking out against racism working to promote communications between the white and black communities of Atlanta. As principle architect of the FABRAP architectural firm, he designed iconic commercial buildings, such as the Georgia Power headquarters, Coca-Cola headquarters, and the former Atlanta–Fulton County Stadium. In the late 1950s, under Mayor William Hartsfield, Alexander led the Citizens Advisory Committee for Urban Renewal. In 2001, Alexander's redesigned version of the Georgia state flag was adopted—omitting the controversial version that portrayed the rebel flag, which had been in use since 1956 .Left, Alexander (left) presents Robert Woodruff (right) with an honorary American Institute of Architects membership. Below, Alexander (left) and longtime friend and civil rights leader Sen. John Lewis discuss the Black-Jewish Coalition, of which they were cofounders. (Courtesy of Judith Augustine.)

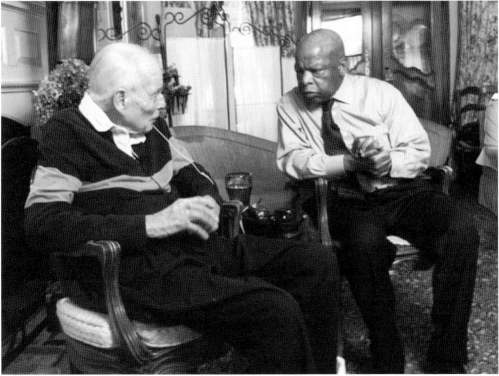

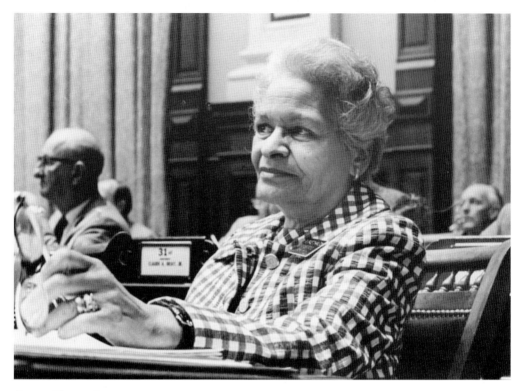

Grace Towns Hamilton

Grace Towns Hamilton was raised to be a community activist. In 1965, she became the first African American woman elected to the Georgia General Assembly. Her first order of business was a bill that ensured Georgia's compliance with the Voting Rights Act. She helped register black voters and was involved in issues of education, health care, and housing. Hamilton was executive director of Atlanta's Urban League and oversaw the revision of Atlanta's city charter in 1973. (Courtesy of AHC.)

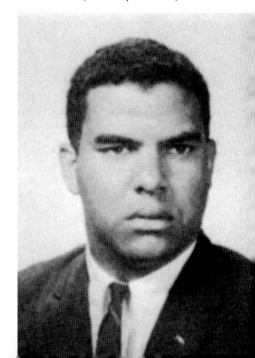

Hamilton Holmes

In 1961, Atlanta native Hamilton Holmes and Charlayne Hunter-Gault were the first two African American students admitted to the University of Georgia in Athens. Two years later, Holmes became the first black student admitted to the Emory University School of Medicine in Atlanta. Holmes earned his medical degree, becoming an orthopedic surgeon. He served as a professor of orthopedics at Emory, as well as an associate dean of the school. (Courtesy of the University of Georgia Hargrett Library.)

CHAPTER FIVE

The Educators

Teachers hold their students' future in their hands. The teachers who have taught us and the administrators who shaped our schools are the people who have helped make us who we are today. From its early beginnings, Atlanta set the pace for changing people's lives. It became apparent early on that education would play a key role in helping keep the pace of the growth.

Civil War veterans Isaac John Fletcher Hanson and Nathaniel Edwin Harris pushed to establish the Georgia School of Technology. Now known as Georgia Tech, its reputation for engineering is world renowned. Dr. K.S. Kendrick played a role in helping Emory College develop what is now a celebrated medical school.

And at a time when segregation was rampant, the push to educate African Americans was stronger in no other city than Atlanta. Spelman College had its beginnings in the basement of Rev. Frank Quarles's church. Atlanta Baptist Female Seminary changed its name to Spelman after John D. Rockefeller's wife, Laura Spelman, when the millionaires decided to endow the school.

John Hope influenced the building of Morris Brown College and, ultimately, Atlanta University in his quest to continue education young blacks.

Still, Atlanta is a city whose public school system has faced its challenges over the decades. While desegregation brought turmoil in other school systems, Atlanta's transition was relatively peaceful and its first black superintendent, Dr. Alonzo Crim not only reorganized the system, but help bring up test scores to previously unheard of levels.

But as rich as the city's history is in education, it is also been home to so incredible innovators. While suffering with sometimes debilitating Tourette syndrome, Brad Cohen inspires his students. Ron Clark takes getting excited about learning to an art form at his Ron Clark Academy.

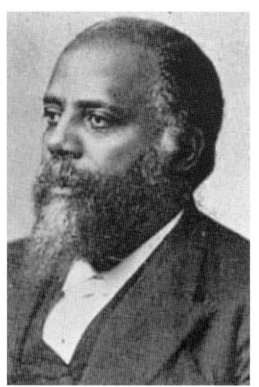

Bishop Wesley John Gaines

A former slave, Wesley John Gaines was passionate about education. He was the second pastor of the Old Bethel African Methodist Episcopal Church and helped organize classes at Clark University. Gaines eventually pushed for his group to create a school of their own. In May 1885, the state granted a charter for the creation of Morris Brown College of the AME Church, the only college in Georgia exclusively for African Americans. (Courtesy of GSA.)

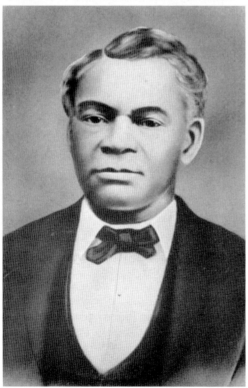

Rev. Frank Quarles

In 1881, Rev. Frank Quarles (pictured) joined forces with New Englanders Sophia Packard and Harriet Giles to start an educational institution for African American females in the basement of his Friendship Baptist Church. Within a year, the Atlanta Baptist Female Seminary had grown to 80 students and purchased a nine-acre site near the school (on which to build). In 1884, the name was changed to Spelman College. (Courtesy of the Spelman College Archives.)

John Fletcher Hanson

A self-made industrialist, John Fletcher Hanson worked with fellow former Confederate officer (and future governor) Nathaniel Harris to create the Georgia School of Technology. The two felt Georgia needed a technical school that would give the state a skilled work force. Hanson used his ownership of the *Macon Telegraph and Messenger* newspaper to help further the idea. Georgia Tech was established October 13, 1995. (Courtesy of Georgia Tech.)

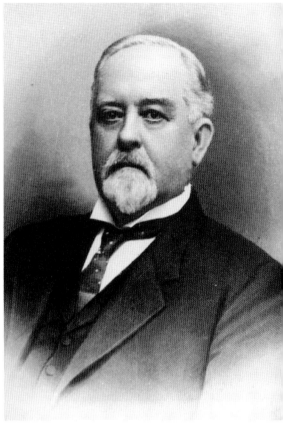

Dr. Isaac S. Hopkins

Atlanta native Dr. Isaac S. Hopkins was president of his alma mater Emory College when he was tapped to take the helm as the Georgia School of Technology's first president. Hopkins was also a professor and first chair of the physics department. He led Georgia Tech for eight years before resigning to become a full-time pastor of First United Methodist Church. (Courtesy of Georgia Tech.)

Dr. William Scott Kendrick
In 1900, Dr. William Scott Kendrick was dean of the Atlanta Medical College when he orchestrated its merger with Southern Medical College. The Atlanta College of Physicians and Medicine was considered the top medical school in the South. In 1905, Kendrick oversaw its name change back to the Atlanta Medical College. In addition to having a successful private practice, Kendrick was a senior professor of medicine at the growing Emory University. (Courtesy of the Woodruff Health Sciences Center, Emory University.)

Selena Sloan Butler
An English teacher and community activist, Selena Sloan Butler was passionate about getting parents involved in their children's education. In 1911, she founded the National Congress of Colored Parents and Teachers Association—the first parent-teacher organization for African Americans in the United States. She later helped create the National Congress of Parents and Teachers, now a part of the National Parent Teacher Association (PTA). (Courtesy of AAL.)

John Saylor Coon

Joining the faculty a year after the school opened its doors, John Saylor Coon was the first professor of mechanical engineering and drawing at the Georgia Technical College. He became the department's first chair and, later, the superintendent of the shops. Known as "Uncle Pys," Coon was beloved not only for his teaching skills, but for his ability to inspire his students. He was called "Tech's Greatest Teacher" by more than one. Coon spent 35 years at Georgia Tech and, upon announcing his retirement, was petitioned by both students and faculty to stay on. He did not. Coons is credited with building the new school's reputation and influencing the policies that would govern the school. While there, he founded the American Society of Mechanical Engineers. (Courtesy of Georgia Tech.)

John Hope

John Hope was a nationally recognized educator and leader of race relations. In 1898, he moved to Atlanta to be a professor at Atlanta Baptist College, eventually becoming its president in 1906. He was the first African American to hold the position. Hope remained president when the college changed its name to Morehouse College in 1913. Working with his activist wife, Lugenia Burns Hope, he reached out to the community to help better understand their needs in the areas of health care, housing, recreation, and employment. In doing so, he was able to impact not just his students, but also the community and the nation. In 1929, he left Morehouse to head Atlanta University Center (AUC). Under Hope, AUC became the first college in the United States to focus exclusively on graduate education for African Americans. (Courtesy of GSA.)

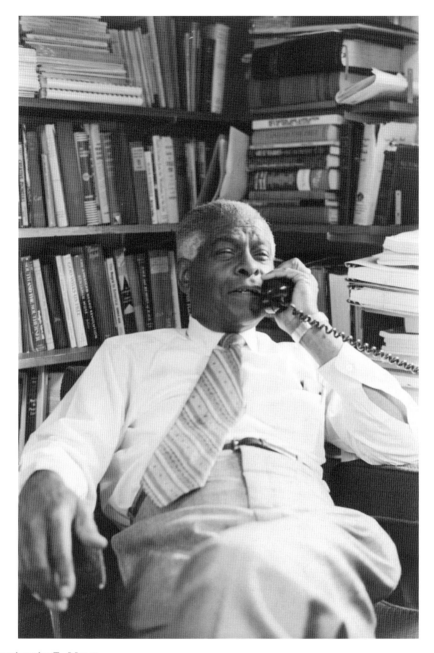

Dr. Benjamin E. Mays
Dr. Benjamin Mays was dean of religion at Howard University in Washington, DC, when he was hired as president of Morehouse College. He held that position from 1940 to 1967. His most famous student was Dr. Martin Luther King, for whom he became a mentor. King sought Mays's counsel on a number of issues. He called upon Mays to deliver the closing prayer for the historic 1963 March on Washington for Jobs and Freedom. Mays also delivered the eulogy at Dr. King's funeral. He was elected president of the Atlanta Public Schools Board of Education in 1967. During his tenure, Mays was able to oversee the peaceful desegregation of area schools. Dr. Mays and his wife, Sadie, are both entombed on the grounds of Morehouse College. (Courtesy of Atlanta Public Schools.)

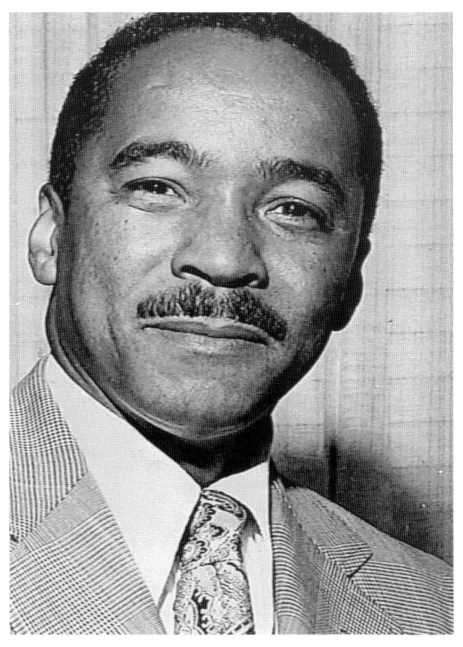

Dr. Alonzo A. Crim

As the first black superintendent of Atlanta Public Schools, Alonzo Crim dedicated his life to creating a system where "students would know that people cared about them." By all accounts, he was successful. In 1973, Crim was hired under a desegregation agreement requiring the hiring of a black superintendent and a balance between white and black school administrators. He was able to successfully reorganize Atlanta public schools and turn around test scores. By his retirement in 1986, student performance levels in basic skills were higher than the national average and the graduation rate had risen 70 percent. At that time, he was also the longest-serving black school superintendent in the nation. (Courtesy of Georgia State University.)

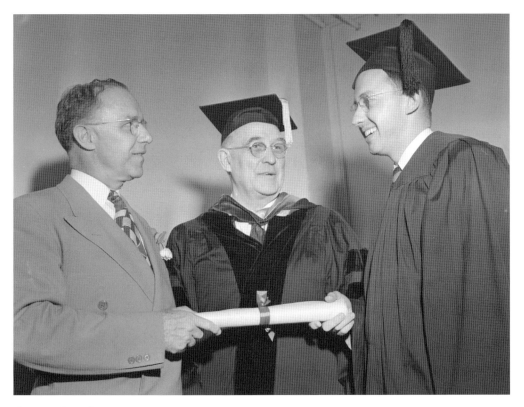

George Sparks

In 1928 when George Sparks became its director, Georgia State University was Georgia Tech's Evening School of Commerce. Sparks oversaw the expansion of the school, its curriculum, and its student body. He pushed for it to separate from Tech. Sparks served as director for 25 years, becoming Georgia State College's first president. Mayor William Hartsfield (left) presents a diploma to his son William Berry Hartsfield Jr. (right) with Dr. Sparks. (Courtesy of AHC.)

Brad Cohen

Brad Cohen is a teacher, school administrator, and motivational speaker. Suffering from severe Tourette syndrome, Cohen graduated with honors from college but was rejected by 24 schools before being hired at Mountain View Elementary School. He later taught at Tritt Elementary before becoming an administrator. He was named Georgia's First Class Teacher of the Year. Cohen authored *Front of the Class: How Tourette Syndrome Made Me the Teacher I Never Had.* (Courtesy of Brad Cohen.)

93

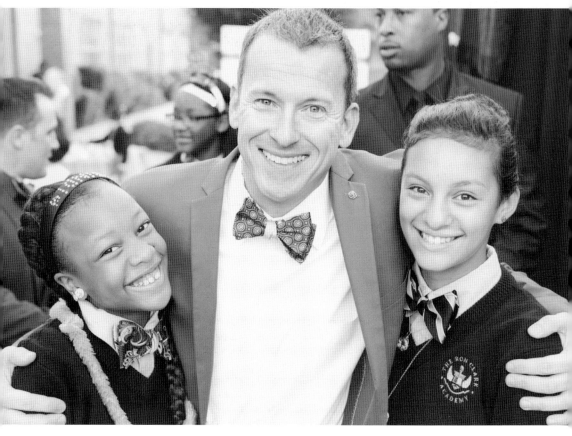

Ron Clark

An educator and founder of the Ron Clark Academy, Clark's passion for education is contagious and has gained him national attention. In 2000, Clark was named Disney's American Teacher of the Year. In 2007, his teaching experiences in New York were depicted in the movie *The Ron Clark Story*, starring Matthew Perry. Clark's book *The Essential 55* landed him on the New York Times bestseller list and has been published in 25 different languages. He's been honored at the White House on three different occasions. In 2007, he moved to Atlanta and partnered with fellow educator Kim Beardon to cofound the Ron Clark Academy. Their innovative and groundbreaking school not only educates children, but also provides professional development experiences for thousands of educators each year. Pictured in the photograph are Mackenzy Jordan (left), Ron Clark (center), and Daryl Ann Coss. (Courtesy of the Ron Clark Academy.)

CHAPTER SIX

Applause

Applause can be dispensed for a wide range of reasons, from performances to a variety of artistic endeavors. From its earliest days, Atlanta was a place that attracted those with a creative flare, making it a cultural center for the South. On these pages, one may meet just a few of those who continue to earn our applause for their impact on the artistic world and who, at one point in their lives, called Atlanta their home.

Their ability as artists, musicians, dancer, and entertainers have made them legends in their lifetime. "Blind Willie" McTell, whose ability to play the blues is something that musicians of today still aspire to emulate, and Gladys Knight, who went from winning a talent contest as a small child to wowing the world with her vocals, are just two examples.

Nipsey Russell went from carhop at the Varsity to a national television star. Fellow comedian Jeff Foxworthy's down-home, redneck humor took him from Atlanta to Los Angeles (before Atlanta beckoned him back home).

Robert Shaw transformed the Atlanta Symphony into an internationally acclaimed ensemble, while Dorothy Alexander's love of ballet helped create the world-class Atlanta Ballet.

And as well recognized as these names are to the world, there are those whose ability to entertain is best known on a local level. The mysterious Catlanta street artist sends people on scavenger hunts to find his whimsical creations. Baton Bob can be seen on any given day marching on Peachtree and twirling to the tune of a different drummer. There are more people who have earned our applause than there are pages in this book. These are but a few.

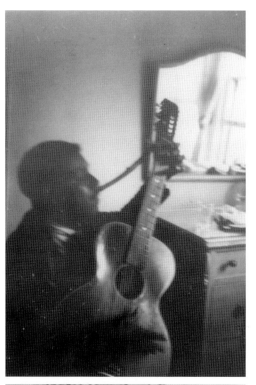

Blind Willie McTell

"Blind Willie" McTell was a living blues legend in the early 1900s. Blind since birth or early childhood, McTell learned to play the guitar as a child and began playing in carnivals, medicine shows, and anywhere else he could find an audience. Using Atlanta as a base, he traveled throughout the United States and was known for his intense rhythms. In 1981, Blind Willie McTell was inducted into the Blues Foundation's Blues Hall of Fame. (Courtesy of LOC.)

Mattiwilda Dobbs

Mattiwilda Dobbs was one of the first black opera singers to earn fame on an international level. The daughter of Atlanta community leader John Wesley Dobbs, she sang in church and community choirs as a child. In 1951, the coloratura soprano made her professional operatic debut at the Holland Festival. Performing throughout Europe, Dobbs was the first black singer to be offered a long-term contract by New York's Metropolitan Opera. (Courtesy of LOC.)

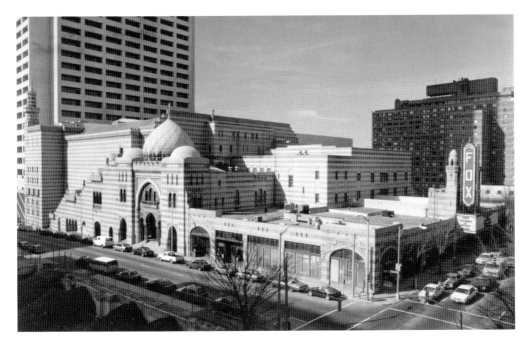

Arthur Lucas and William Jenkins

Atlanta's Fox Theatre had its beginnings as the Yaarab Temple Shrine Mosque. It opened just after the stock market crash of 1929 and was in financial straits until, in 1934, it came under the management of Arthur Lucas (right) and William K. Jenkins. Although the two had a history running community theaters, this was their first movie theater. Lucas and Jenkins's experience as promoters proved to be what the Fox needed. They ran contests and offered promotions, turning the Fox into a premier location for movie watching. In 1939, Lucas and Jenkins formed the Georgia Theater Company to manage other theaters. By the time Lucas died in 1943, the two had more than 50 theaters across Georgia. (Courtesy of the Fox Theatre.)

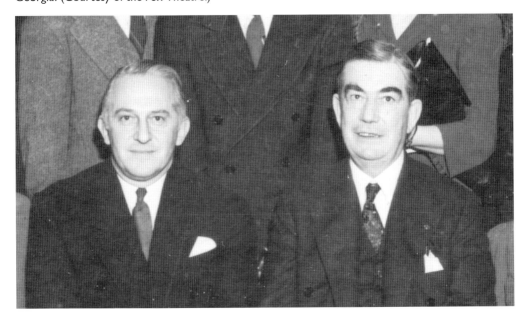

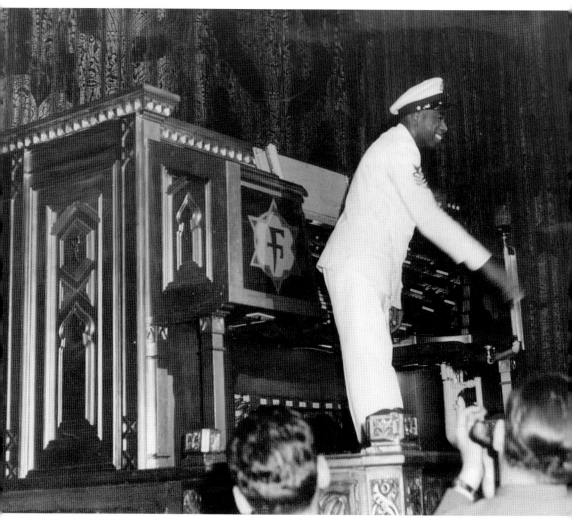

Graham Jackson

From an early age, Graham Jackson had the ability to master almost any instrument. However, he showed a particular love for the organ and piano. His career took off after he became the featured performer at Atlanta's Royal Theater and gave concerts at the Fox Theatre on its acclaimed Moeller organ. Known as the "Ambassador of Good Will," Jackson toured extensively both on a national and international scale. He became a personal friend of Pres. Franklin D. Roosevelt and visited him often at "The Little White House" in Warm Springs, Georgia. After FDR's death, it is Jackson who is seen tearfully playing an accordion in the iconic photograph that shows the train that carried the president's body back to Washington. In 1971, Gov. Jimmy Carter named him "Official Musician of the State of Georgia." (Courtesy of the Fox Theatre.)

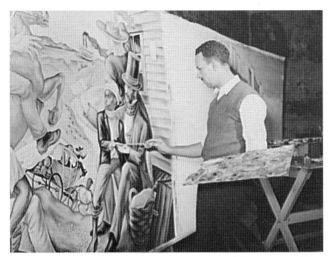

Hale Woodruff
Hale Woodruff made his name as an abstractionist by painting works that emphasized African symbolism, particularly lynching and poverty. After traveling and painting in Europe, Woodruff returned to the United States in 1931 and established the art department at Atlanta University, where he taught for more than a decade. Woodruff is best known for three panels of murals known as the Armstad murals at the Talladega College Savery Library in Alabama. (Courtesy of LOC.)

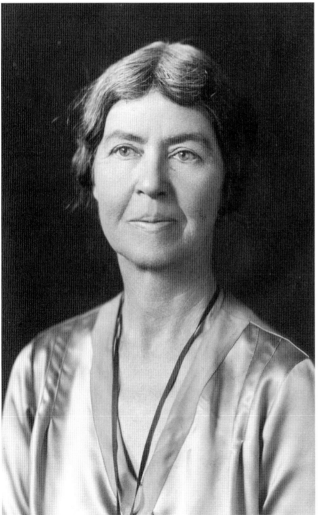

Lucy May Stanton
As an artist, Lucy May Stanton depicted her subjects with realism. A prolific painter, she worked in a variety of mediums but was best known for her intricate portrait miniatures. Slanton became an art lecturer and was involved in the women's suffrage movement. She cofounded the Georgia Peace Society in 1928 and helped campaign for the League of Nations. (Courtesy of UGA.)

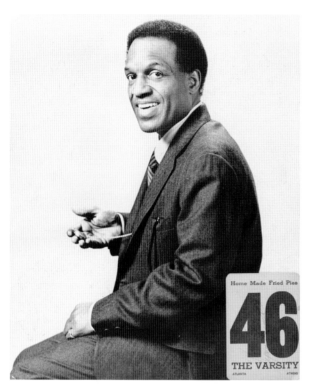

Nipsey Russell

Atlanta native Julius "Nipsey" Russell used comedy to increase his tips while working as the No. 46 curb boy at the Varsity drive-in. Russell had a successful standup comedy act, starring in movies and game shows. When he joined ABC's show *Missing Links* in 1964, Russell became the first black performer to become a regular game show panelist. He is known for his humorous poems, which earned him the nickname "the poet laureate of television." (Courtesy of the Varsity.)

Dorothy Alexander

Dorothy Alexander studied dance in New York and London before returning to her hometown of Atlanta to open the La Petite École de Dance in 1921 (now known as the Atlanta School of Ballet). By 1929, she had organized the first regional ballet company in the United States, the Atlanta Ballet—now the longest continually performing ballet company in the nation. (Courtesy of the Atlanta Ballet.)

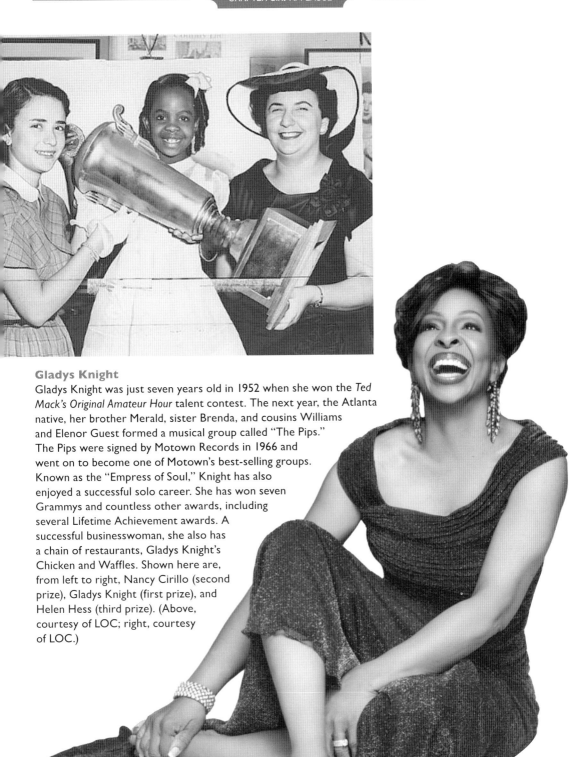

Gladys Knight

Gladys Knight was just seven years old in 1952 when she won the *Ted Mack's Original Amateur Hour* talent contest. The next year, the Atlanta native, her brother Merald, sister Brenda, and cousins Williams and Elenor Guest formed a musical group called "The Pips." The Pips were signed by Motown Records in 1966 and went on to become one of Motown's best-selling groups. Known as the "Empress of Soul," Knight has also enjoyed a successful solo career. She has won seven Grammys and countless other awards, including several Lifetime Achievement awards. A successful businesswoman, she also has a chain of restaurants, Gladys Knight's Chicken and Waffles. Shown here are, from left to right, Nancy Cirillo (second prize), Gladys Knight (first prize), and Helen Hess (third prize). (Above, courtesy of LOC; right, courtesy of LOC.)

Robert Shaw

Robert Shaw was renowned as possibly the greatest conductor of choral music in the United States. Shaw was music director and conductor of the Atlanta Symphony Orchestra for 21 years, transforming the regional ensemble into an internationally acclaimed orchestra. He also created the celebrated ASO Chorus and the ASO Chamber Chorus. After his retirement from the Atlanta Symphony, he created the Robert Shaw Choral Institute and conducted yearly choral workshops at New York's Carnegie Hall. In 1991, he was a recipient of the Kennedy Center Honors—the nation's highest honor for artists and an award for those "who, through a lifetime of accomplishment, have enriched American life by their achievement in the performing arts." (Courtesy of the Atlanta Symphony Orchestra.)

Brenda Lee

Brenda Mae Tarpley was born in Atlanta's Grady Hospital. Her first singing performance was at the age of five, representing Conyers Grade School in a talent contest. In 1956, she got her first recording contract with Decca Records and became known as Brenda Lee at the tender age of 13. Three years later, her rockabilly, pop, and country talents had made her an international star. During the 1960s, only Elvis Presley could boast more chart-topping singles. (Courtesy of Brenda Lee Productions.)

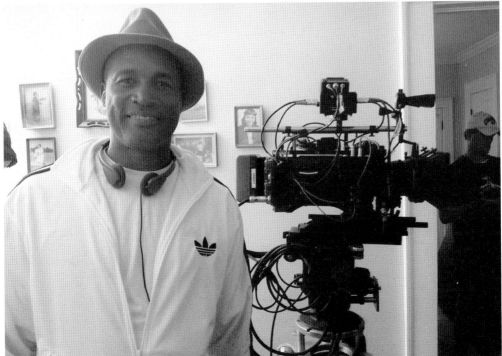

Kenny Leon

Kenny Leon first gained attention when he took the helm of Atlanta's Alliance Theater in 1988, working with such notable playwrights as Pearl Cleage and Alfred Uhry. He staged the premiere of Sir Elton John and Tim Rice's *The Lion King*, which went on to Broadway. Leon has also directed movies, including Lifetime's remake of the movie *Steel Magnolia*. He's the founder and artistic director of the True Colors Theatre in Atlanta. (Courtesy of True Colors)

Ty Pennington

Ty Pennington worked his way through school at the Atlanta College of Art as a carpenter. After graduating, he worked as a model, ultimately combining looks and skill as a designer on the cable television show *Trading Spaces*. He hosted ABC's *Extreme Makeover: Home Edition* for eight years, building more than 200 homes for deserving families. Pennington designs for his company, Furniture Unlimited. (Courtesy of Ty Pennington.)

RuPaul Andre Charles

Known for his flamboyant drag-queen persona, RuPaul Andre Charles moved to Atlanta as a teenager and attended Northside High School. He struggled as a musician, filmmaker, and actor before gaining attention as a dancer in the B-52's music video for "Love Shack." RuPaul has become one of the best known drag queens in history, but has performed in both male and female roles. In 2009, LOGO television began airing the reality show *RuPaul's Drag Race*. (Courtesy of Mathu Andersen.)

Jeff Foxworthy

Jeff Foxworthy started his career in the corporate world working at IBM. In 1984, he entered and won an open mike competition at Atlanta's Punch Line comedy club. Ditching his white-collar job for blue-collar comedy, he quickly became a crowd favorite. He is known for his ability to laugh at his Southern roots and for explaining why "you might be a redneck." Foxworthy has starred in his own self-titled sitcom and several sketch comedy shows, hosting dozens of others. (Courtesy of Parallel Entertainment.)

Catlanta

Anonymous street artist Catlanta creates works of art featuring his iconic Catlanta kitten. He then sends fans on scavenger hunts via social media to find them. Since starting in 2010, hundreds of Catlanta kittens have been placed near Atlanta landmarks. The kittens are all unique, but all feature his iconic three-legged Catlanta character. Among those commissioning Catlanta pieces are the HIGH Museum, Zoo Atlanta, the Renaissance Hotel, FLUX, the Living Walls Conference, and the 2013 NCAA Final Four. (Courtesy of Charlene Chae.)

Baton Bob Jamerson
Bob Jamerson began twirling a baton as a child in Virginia. He made his living as a florist until the tragedy of 9/11. Jamerson then picked up his baton again and become the self-proclaimed "Ambassador of Mirth." He moved to Atlanta, donned his marching boots, and took to the streets as "Baton Bob." His persistent smile and elaborate costumes have made him a fixture throughout the downtown and midtown areas. (Courtesy of Bob Jamerson.)

Blondie Strange
Even those who have not frequented Atlanta's seedy Clermont Lounge have heard of the legendary Blondie. She began pole dancing and stripping there in the 1970s and quickly developed a cult following because of her campy burlesque showmanship. She is best known for her ability to crush beer cans with her breasts. (Courtesy of Tatum Shaw.)

CHAPTER SEVEN

About the Words

Writing is an art, and there are those who can paint a picture like no other. The true artists can use their words to exact change or to let their audience escape.

Many of those noted in this chapter go back to the early days of journalism when writers, reporters, and editors helped control political activities through the daily paper. The *Atlanta Constitution* newspaper was a powerful force both following the Civil War during Reconstruction and as the move to desegregate began growing. People like Henry Grady and Ralph McGill were legends for standing their ground when it was not always popular to do so. McGill, in particular, came under fire during the civil rights movement for his stance for equality for all.

Atlanta has both lured writers and inspired them. Alfred Uhry's "Atlanta Trilogy" of plays garnered him awards. Lewis Grizzard's comedic interpretation of life in Atlanta made him an international sensation. Celestine Sibley's folksy take on everyday life made her a favorite among readers of her column. It's hard to believe she started her career as a crime reporter.

There are those included here whose works are still celebrated today. Margaret Mitchell's novel *Gone with the Wind* is something that visitors to Atlanta find themselves using as a guide to landmarks around town. Joel Chandler Harris's folksy African American tales changed the literature of his day, because he wrote in a manner that showed how his characters would actually pronounced words. No one had ever done such a thing!

Many of the people mentioned here are award winners, and for good reason. Most of them have used Atlanta, or their time spent there, as their motivation.

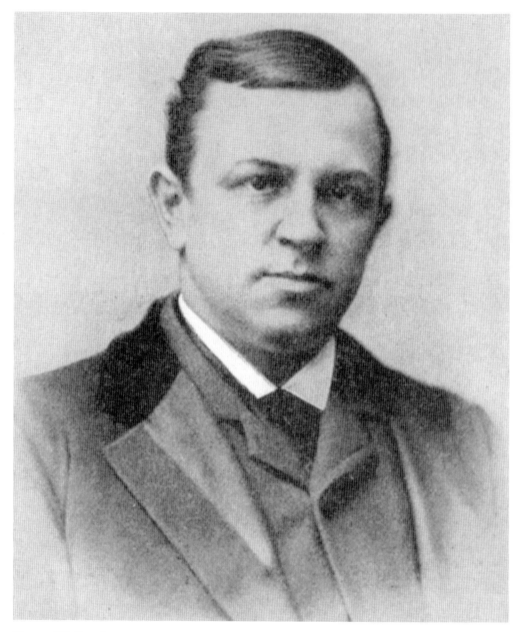

Henry W. Grady

Journalist Henry Grady was considered the voice of the "New South." The newspaperman worked in Rome, Georgia, and New York City before moving to Atlanta, where he quickly rose to be managing editor and part owner of the *Atlanta Constitution*. An advocate of railroad development and industrialization, he used the newspaper to promote his platform and to help bring businesses to Georgia. Grady, a well-known orator, told a group of New York businessmen in 1886, "There was a South of slavery and secession—that South is dead. There is now a South of union and freedom—that South, thank God, is living, breathing, and growing every hour." A supporter of white supremacy, he also endorsed Prohibition. Grady was instrumental in winning approval for the founding of the Georgia Institute of Technology. (Courtesy of LOC.)

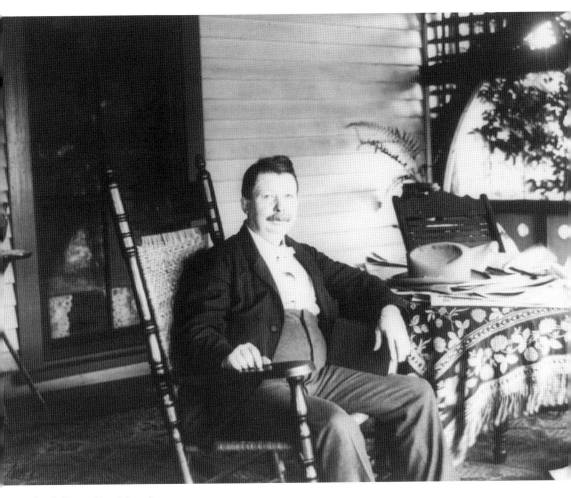

Joel Chandler Harris

Joel Chandler Harris is best known as the writer of African American folk tales about "Uncle Remus and Br'er Rabbit." Having served as an apprentice on a plantation in Eatonton, he drew many of his tales from his experiences there. A prolific writer, Harris wrote numerous tales about Br'er Rabbit in a style that transformed the literary world of his day. Harris wrote novels and children's books, and even translated French folklore. He also had another life, that of a reporter for the *Atlanta Constitution* under Editor Henry Grady. Harris was vocal in denouncing racism and promoting African American education and suffrage in his works. His farmhouse on the outskirts of Atlanta, which he named the Wren's Nest, was where Harris did much of his writing. The Wren's Nest now houses his museum. (Courtesy of LOC.)

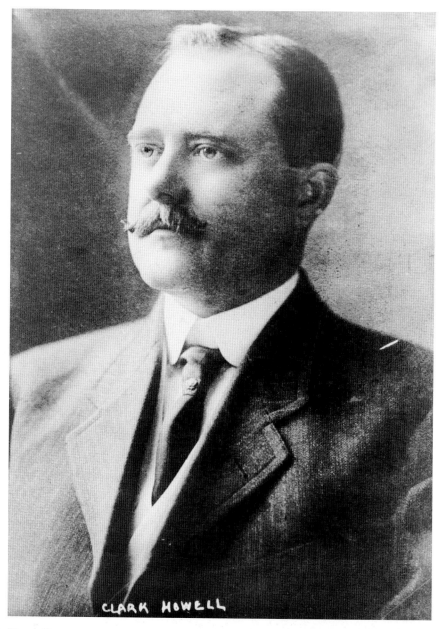

CLARK HOWELL

Clark Howell

Clark Howell was a politician and a journalist, winning accolades in both arenas. In 1931, he won the Pulitzer Prize for exposing graft in Atlanta city government, which led to the downfall of Mayor I.N. Ragsdale. In 1901, Howell was editor of the *Atlanta Constitution* when he purchased the newspaper. He was one of the original directors of the Associated Press, a position he held from 1900 until his death in 1936. Howell served on the Fulton County Board of Commission and was elected to terms in both the Georgia House and the Georgia Senate. Howell's reputation for integrity made him a favorite of presidents. Pres. Warren Harding appointed him to a special mining commission, while Pres. Herbert Hoover tapped him to serve on the National Transportation Commission. Howell was chairman of the Federal Aviation Commission under Pres. Franklin Roosevelt. (Courtesy of LOC.)

Frank Lebby Stanton

Frank Lebby Stanton moved to Atlanta to become a columnist for legendary *Atlanta Constitution* publisher Henry Grady. His gift for prose meant he was called upon to create poetry for almost any special occasion. In 1925, he was appointed Georgia's first poet laureate by Gov. Clifford Walker. The appointment also made him the first poet laureate of any Southern state. Stanton was a well-known lyricist of his time. (AHC.)

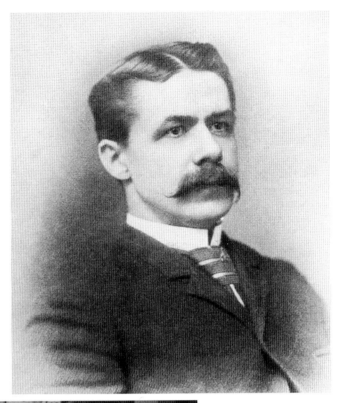

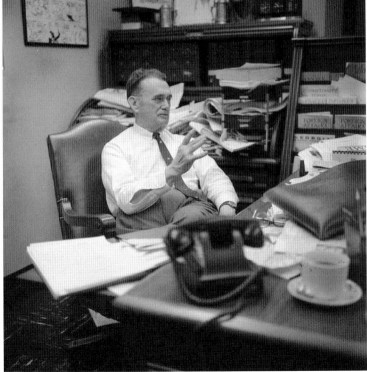

Ralph McGill

As publisher for the *Atlanta Constitution*, Ralph McGill won the 1959 Pulitzer Prize for his editorials, which spoke out against segregation. From the 1940s to the 1960s, he was an influential voice in calling for racial tolerance. While vilified by segregationists, he was often referred to as the "Conscious of the South." A voracious reader, McGill wrote more than 10,000 columns and four books during his career.

Margaret Mitchell

A lifelong resident of Atlanta, Margaret Mitchell began writing stories almost as soon as she was old enough to pick up a pen. Her family was both wealthy and politically prominent and, as head of the local women's suffrage movement, her mother, Maybelle, encouraged her daughter to be independent and opinionated. Young "Peggy," as she was known, wrote tales of adventure, but had little self-confidence as to just how good her works actually were. In need of a job after divorcing her first husband, Red Upton, she took a position writing at the *Atlanta Journal Sunday Magazine* in 1923. She earned accolades for her descriptive articles. An ankle injury forced her to quit her job four years later, and her second husband, John Marsh, bought her a typewriter to keep her occupied. The result was the novel *Gone with the Wind*. The Civil War–era novel took her three years to write and another six years to find a publisher. Published in 1936, the novel won a Pulitzer Prize for fiction a year later. In 1939, MGM studios transformed Mitchell's novel into a movie starring Clark Gable and Vivian Leigh. *Gone with the Wind* was the only novel Mitchell had published during her lifetime. (Courtesy of AHC.)

Alfred Uhry

Atlanta-born Alfred Uhry was a struggling lyricist and playwright in New York when he turned his talents toward writing his "Atlanta Trilogy" plays. *Driving Miss Daisy* earned him a Pulitzer Prize for drama, and his screenplay for the movie of the same name garnered him an Academy Award for Best Adapted Screenplay. Uhry's next two plays, *The Last Night of Ballyhoo* and *Parade*, both won acclaim on Broadway and earned Tony Awards. (Courtesy of Alfred Uhry.)

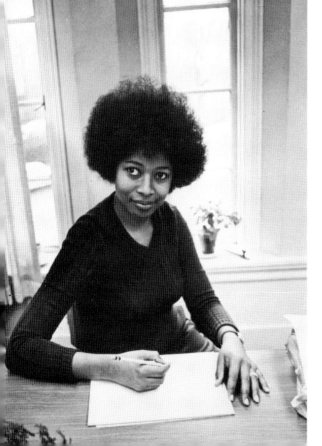

Alice Walker

When Alice Walker won her Pulitzer Prize for fiction for *The Color Purple*, she was the first African American woman to do so. The novel was adapted into both an Academy Award–winning movie and a Tony Award-winning Broadway musical. As a student at Spelman College, she marched with Dr. Martin Luther King, thus beginning a lifetime of activism. Walker is also a celebrated poet and writer of short stories. (Courtesy of Emory MARBL.)

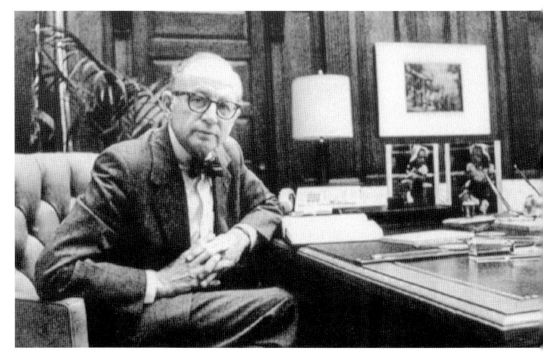

Daniel Boorstin
A historian, attorney, and professor, Daniel Boorstin won the Pulitzer Prize for literature in 1974 for the third of his Americans trilogy, *The Americans: The Democratic Experience*. The Atlanta native was a prolific writer, writing more than 20 books about social history. Boorstin served as the 12th librarian of the US Congress from 1975 to 1987. (Courtesy of LOC.)

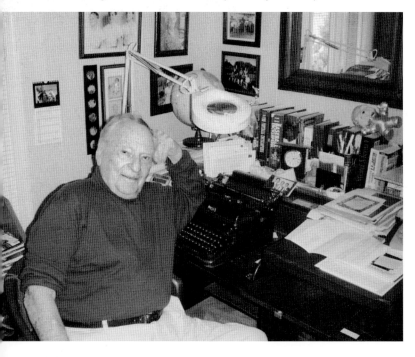

Furman Bisher
Furman Bisher was considered one of the all-time great sports writers. He began working for the *Atlanta Constitution* in 1950 and spent 59 years as a sports reporter, columnist, and editor. He wrote his final column on the same typewriter that he wrote his first. By his own estimate, in his career he had written 15,000 daily sports columns, 1,200 magazine articles, and more than a dozen books. (Courtesy of Brian Estes.)

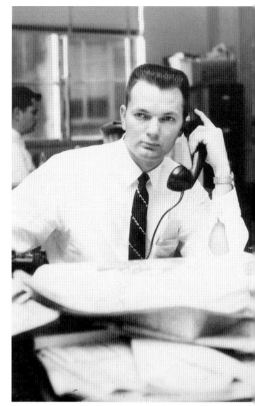

John "Jack" Nelson
Jack Nelson earned the nickname "Scoop" early in his newspaper career because of his aggressive tactics. While working at the *Atlanta Constitution* in 1960, he won the Pulitzer Prize for his exposé of the conditions at the Georgia state sanitarium. Nelson became the Washington, DC, bureau chief for the *Los Angeles Times* and led its coverage of the Watergate scandal. (Courtesy of Emory MARBL.)

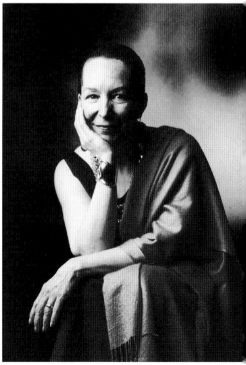

Pearl Cleage
Pearl Cleage's first novel, *What Looks Like Crazy on an Ordinary Day,* spent nine weeks on the *New York Times* best-seller list and garnered her a spot as a 1998 selection for Oprah Winfrey's Book Club. The Spelman College graduate is also a playwright, poet, journalist, and teacher. She lectures frequently on the topics of racism, sexism, domestic violence, and rape. (Courtesy of Albert Trotman.)

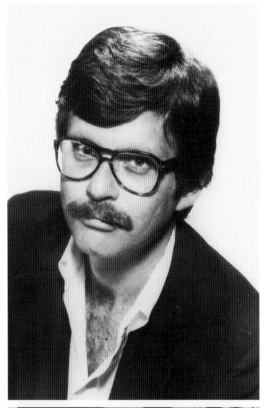

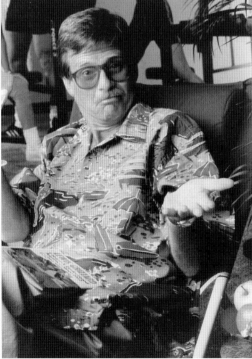

Lewis Grizzard

Lewis Grizzard started his career as a sports writer, but it didn't take long for his humor to lead him to his true calling—humor. As a columnist for the *Atlanta Constitution*, Grizzard gained enduring popularity with his self-deprecating commentary. He refused to use a computer, writing all of his columns and books on a typewriter. He wrote 25 books in his lifetime, all of which remain in print. Their quirky titles included his popular *Elvis Is Dead and I Ain't Feeling So Good Myself* and *Don't Bend Over in the Garden, Granny, You Know Them Taters Got Eyes*. Grizzard was also a popular lecturer and standup comedian. After his death, he was cremated and his ashes scattered on the 50-yard line of Sanford Stadium, the football field of his beloved University of Georgia. (Courtesy of Dedra Grizzard.)

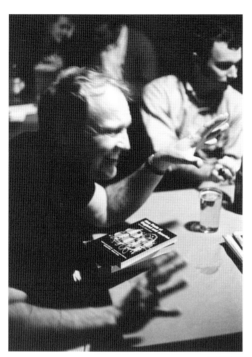

James Dickey
Although best known to many as the author of the gritty novel *Deliverance*, Atlanta-born James Dickey also was also a critic, teacher, and critically acclaimed poet. In 1966, he was appointed the 18th Poet Laureate Consultant in Poetry to the Library of Congress. A winner of numerous awards for his prose, Dickey composed a poem for fellow Georgian Jimmy Carter's presidential inauguration in 1977. (Courtesy of Georgia Tech.)

Pat Conroy
Atlanta native Pat Conroy has drawn from personal experiences as the basis of some of his most popular novels. His 1972 novel *The Water Is Wide,* about teaching underprivileged children on South Carolina's Daufuskie Island, brought him critical acclaim and was the basis for the movie *Conrack*. *The Lords of Discipline, The Great Santini, The Prince of Tides,* and *South of Broad* all mirror aspects of his own storied life. (Courtesy of Jennifer Hitchcock.)

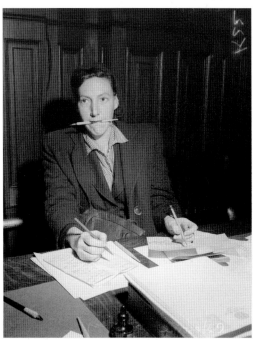

Celestine Sibley

An author, humorist, and journalist, Celestine Sibley worked as a reporter for the *Atlanta Constitution* from 1941 to 1999. While she began her career as a general assignment reporter, covering everything from crime to features, it was her syndicated column in the paper that made her a Southern icon. She wrote more than 10,000 columns in her career on a wide range of topics. Sibley also wrote nearly 30 books. (Courtesy of AHC.)

Mike Luckovich

In this drawing, political cartoonist Mike Luckovich depicts himself on the face of Stone Mountain. In 1984, he began his career in Greenville, South Carolina, but made his mark after joining the *Atlanta Journal-Constitution* in 1989. Nationally recognized for his biting satire, Luckovich won the Pulitzer Prize for editorial cartoons in 1995 and again in 2006. The National Cartoonists Society awarded him the Reuben Award for Outstanding Cartoonist of the Year in 2005. (Courtesy of Mike Luckovich.)

CHAPTER EIGHT

The Contributors

While the chapters in this book have some definitive topics, there are those who do not fit into a well-defined category, or at least not in a category that includes peers from Atlanta one could celebrate. These are the people who will be referred to as "The Contributors."

This chapter is devoted to some unique individuals who have made an important contribution to history, a sport, a community, or society, and who truly stand alone in their accomplishments.

Some of these names are easily recognizable, like John Heisman, for whom the famous football award is named. But there are others, like John Gill, who, while internationally heralded, are not as well known in their own former hometown.

Thomas Askew's name may not be as recognizable as Ansel Adams, but no one depicted the lives of African Americans in the late 1800s and early 1900s as he did. His photographs were shown on an international level, which was unheard of at the time. Joe Patten is known as the "Phantom of the Fox" because of his apartment in the building of the historic theater. But to others, he is the "Savior of the Fox," having worked tirelessly to at first simply keep the theater in working order, but secondly to keep it from being torn down. Marvin Gardens has been gone for years, but in his day, he was the person everyone wanted to help throw their soirée. If flowers were needed from an exotic locale, Gardens was the man. Consumers in Atlanta know to turn to Clark Howard for advice or to help get action. Howard's message now has a national audience as well.

This chapter helps celebrate those whose contributions should simply not go uncelebrated because they, too, are local legends.

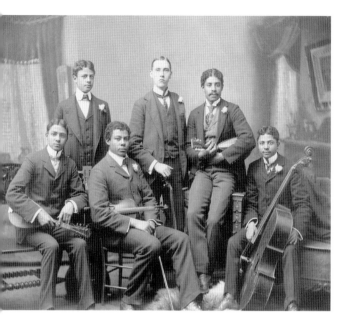

Thomas Askew

Opening a photography studio in the 1880s, Thomas Askew (pictured in the self portrait at right) became Atlanta's first black photographer. He was considered a master of lighting and composition. Many of his photographs appeared in W.E.B. Du Bois's *Georgia Negro Exhibit*, which premiered in Paris in 1900. The photograph above includes, from left to right, Clarence and Norman Askew (Askew's twin sons), Arthur Askew (son), Jake Sansome (neighbor), and Robert and Walter Askew (sons). (Courtesy of LOC.)

Maybelle Mitchell

While some may know her as *Gone with the Wind* author Margaret Mitchell's mother, Mary Elizabeth "Maybelle" Mitchell was known for her numerous civic roles. A proponent of education and women's rights, she was the president of the Atlanta Woman's Suffrage League in 1915 and later served as president of the Atlanta Board of Education. She was also active in numerous church and literary societies. (Courtesy of AHC.)

AIN'T YER, COACH?

He ain't no doc or lawyer
An' he aint' no president,
He ain't no people's pony
With a million dollars spent,
But his heart's all right an' mellow
An' he's just a darn good fellow,
 Ain't yer, Coach?

He'll yell and cuss and bawl yer
When yer fumble o'er a play,
An' he'll tell yer that yer rotten
Make yer run around all day,
Though he works yer and he moves yer,
Yer kin bet 'cher boots he loves you.
 Don't yer, Coach?

Sometimes he seems like snowing
He's so harsh an' stern and cold,
Yet he's nothing but a youngster
Though his days would call him old,
An' we never mind his manny
Fer he gits old Georgia's nanny,
 Don't yer, Coach?

Ther boys they all stick by him,
For they know that he's a friend,
Ther kind yer like to freeze ter
Fer he helps yer ter ther end,
An' in athletic show off, well,
He's just ther best we know of,
 Ain't yer, Coach?
 —The Blue Print, 1915.

John Heisman

College football's prestigious Heisman Trophy was named for former Georgia Tech coach John Heisman. Between 1904 and 1919, Heisman coached football, basketball, baseball, and even track, leading Tech to the 1917 National Football Championship. While at New York's Downtown Athletic Club, he initiated the "Downtown Athletic Club" trophy for the country's best college football player. It was renamed in his honor. Heisman studied law before choosing a career in coaching. He was also a writer and a trained Shakespearean actor. (Courtesy of the John M. Heisman Family Collective Archives.)

Bobby Jones

An Atlanta attorney, Robert Tyre "Bobby" Jones was also the most successful amateur golfer ever to compete on a national and international level. He routinely beat professional players but chose to remain an amateur. He was the only golfer to win the Grand Slam, the US Amateur, the US Open, the British Amateur, and the British Open Championships in the same year. Jones helped design and found Augusta National Golf Course in 1933. (Courtesy of LOC.)

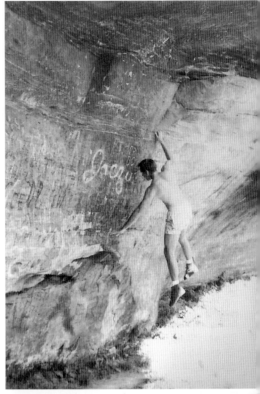

John Gill

John Gill was an amateur gymnast when he became intrigued with rock climbing. He incorporated gymnastic moves into traditional rock climbing, even introducing the use of gymnastic chalk for gripping, a technique now used throughout the world. Gill's artistic feats involving difficult terrain led other climbers to refer to him as the "Father of Modern Bouldering." The internationally acclaimed mathematician went to high school in Atlanta and attended Georgia Tech. (Courtesy of John Gill.)

Freddy Lanoue

Georgia Tech swimming and diving coach Freddy Lanoue developed a water survival method designed to keep even non-swimmers from drowning in disaster situation. His "drown-proofing" method was soon a graduation requirement at Tech and was made a part of the US Navy's standard training. As part of the test, swimmers had to learn to float with their hands and feet tied. (Courtesy of Georgia Tech.)

Dante Stephensen

Chicago-born Dante Stephensen was a Navy frogman when he was tapped to help develop the first elite SEAL team. After moving to Atlanta in 1966, he opened his jazz restaurant, Dante's Down the Hatch, in Underground Atlanta in 1970. A second location opened in 1981. At the time of its closing in 2013, it was the oldest jazz club in the United States under the same ownership. A railroad buff, Stephensen also served as president of American Association of Private Railroad Car Owners. (Courtesy of Dante Stephensen.)

Marvin Gardens

Maybe it was the name that started it all, but in the 1970s and 1980s, Marvin Gardens was the premier party and entertainment designer in the city of Atlanta and beyond. Known as the "Florist to the Stars," Gardens's client list was a who's who of Atlanta, and he counted countless stars among his friends. When asked, he could tell you any star's favorite flower. Garden is shown here with Audrey Hepburn. (Courtesy of Mishelle Gorman.)

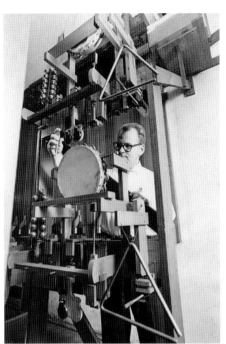

Joe Patten

Joe Patten was a trained x-ray technician. He learned to repair organs and was recruited by the American Theatre Organ Association in 1963 to restore the 1929 Moeller organ at Atlanta's Fox Theatre. Patten worked without pay for six months to get the Mighty Mo playing again. When the Fox was threatened with demolition in 1974, Patten helped lead the cause to "Save the Fox." (Courtesy of the Fox Theatre.)

Jerry Thomas

Jerry Thomas started his career in sports management, but his passion for African American and African art led him down another path. An attorney, he began working as a broker and consultant, handling cases involving nationally renowned collector/dealers and art institutions. Thomas is an internationally recognized expert on buying and selling African and African American art. His expertise includes the artistic, cultural, and investment aspects of arts. (Courtesy of Jerry Thomas.)

Monica Pearson

In 1975, Monica Pearson (known as Monica Kaufman until 2005) joined the staff of WSB-TV in Atlanta as the first woman and first minority to anchor the 6:00 p.m. news. Her storied 27-year career at WSB garnered her 30 Local and Southern Emmy Awards and countless other accolades. Her prime-time specials, *Monica's Close-Ups*, ran periodically over a course of 20 years, during which she interviewed more than 170 celebrities. (Courtesy of WSB-TV.)

Clark Howard

Clark Howard became a nationally recognized consumer expert by accident. After selling his travel agency and retiring at the age of 31, he was asked to be a guest on a radio show for advice on travel. With his expertise in demand, he launched the nationally syndicated *Clark Howard Show*. Howard offers advice in a weekly newspaper column. He is Atlanta's WSB-TV consumer reporter and contributes to cable's HLN. (Courtesy of Kate K. Moore.)

INDEX

INDEX

Find more books like this at
www.legendarylocals.com

Discover more local and regional history books at
www.arcadiapublishing.com

Consistent with our mission to preserve history on a local level, this book was printed in South Carolina on American-made paper and manufactured entirely in the United States. Products carrying the accredited Forest Stewardship Council (FSC) label are printed on 100 percent FSC-certified paper.